Contents

Introduction – Claire Wilcox 6

Court and Country | 1750–1820 10

Taking the Air | 1790–1830 20

In Society | 1810–1830 28

At Home | 1825–1840 34

The Male Wardrobe | 1840–1875 42

The White Wedding | 1840–1860 48

Fashion and Industry | 1850–1870 56

Couture and Commerce | 1870–1910 64

The Cult of the Kimono | 1905–1915 76

Bright Young Things | 1920–1930 84

The Modern Woman | 1925–1940 92

Tailored to Fit | 1940–1960 102

The Pursuit of Perfection | 1947–1960 110

Revolution | 1960–1969 122

Patterning Fashion | 1967–1975 130

Deconstructing Fashion | 1975–1985 138

Fashion Now | 1990–2012 146

Further Reading and Collections 160

Introduction

The Victoria and Albert Museum's fashion collection is one of the most significant and comprehensive in the world. It houses an outstanding range of fashionable dress from the seventeenth century to the present day. This book highlights a number of remarkable examples from the collection, from a 250-year-old brocaded silk court mantua (gown) with an extravagantly wide petticoat, an 1885 dolman jacket of silk velvet trimmed with Arctic fox fur, to an evening dress made entirely of silvered leather by the contemporary British designer Gareth Pugh. Accessories provide the punctuation point in fashion, and the Museum holds an abundance of fans, purses, bags, shoes and hats. They range from the luxurious – such as a silk parasol of 1900 with gold enamel and a diamond handle by the Russian jeweller Fabergé – to the witty, in the form of a miniaturized top hat with veil from 1938 by the Italian couturier Elsa Schiaparelli, and, sometimes, to the functional, as in a pair of Dr. Martens work boots (pls 1, 75, 78, 103, 157, 184).

The Museum was established in 1852, following the popular success of the Great Exhibition of 1851, with a founding principle to make works of art available to all, a 'school room' to educate working people and to inspire British designers and manufacturers. Profits from the Exhibition were used to establish the Museum of Manufactures, as the V&A was initially known, and exhibits were purchased to form the basis of its collections, including textiles. Initially dress was acquired for the technical quality and design of the woven, printed or embroidered textiles from which it was made rather than for its fashionable significance. However, by the 1890s the aesthetic appeal of dress became increasingly appreciated amidst a wider interest in British history. In 1900 the Museum acquired the Isham Collection, 31 important examples of seventeenth- and eighteenth-century dress and textiles, declaring that 'the history of English costume is being increasingly recognized as a subject of serious study, not only for purposes connected with literature and art, but also for the practical purposes of daily life'. Historical dress has also served a practical purpose for genre painters, such as Talbot Hughes, whose collection of 1,442 items of male and female dress, from the mid-eighteenth century to the 1870s, was a reference library of dress styles. Purchased by Harrods and exhibited in the department store, it was presented to the Museum in 1913 (pl.15).

Despite the disruption caused by the First and Second World Wars, the collections continued to grow. In 1942 the Board of Trade gave its prototype Utility collection, designed by members of the Incorporated Society of London Fashion Designers, to the V&A. The economical cut and restrictions on fastenings and trimmings allowed reflected the particular conditions of war. Despite this, British *Vogue* regarded fashion as playing an essential role in maintaining morale. In 1957, the Museum's first dedicated fashion curator was appointed, soon to oversee the acquisition of over 100 items of Edwardian dress that had belonged to a wealthy Londoner, Miss Heather Firbank. This resulted in one of the Museum's first fashion exhibitions, *A Lady of Fashion*, in 1960. The Firbank collection was followed in 1967 by that of Miss Emilie Grigsby, an American socialite known for her 'pale beauty and golden hair', who patronized the top French and British couturiers. Her yellow wool mantle cut like a kimono by Paul Poiret, and evening coat created from Japanese brocade by the London designer Anne Talbot, reflected the early twentieth-century craze for Asian-inspired design (pls 80, 86, 90, 113).

In 1971 the photographer Sir Cecil Beaton persuaded his aristocratic and stylish friends to donate 1,200 items of haute couture to the V&A for the exhibition *Fashion: An Anthology*. This remarkable collection, with its distinguished provenance, forms the nucleus of the twentieth-century collections, while the exhibition, with its dramatic styling, marked the beginning of modern fashion curation. Exhibitions and displays began to proliferate, such as *Fashion 1900–1939* (1976), *Yuki* (1978), followed by *The Little Black Dress* (1983), *Pierre Cardin*

(1990), *Dressing the Part: Henry Poole and Co., Savile Row tailors* (1996) and *The Cutting Edge* (1997).

The twenty-first century began with *One Woman's Wardrobe*, based on a large collection of items donated by Lady Ritblat in 2000. Temporary displays offered an opportunity to focus on individual designers such as Ossie Clark, or style icons such as Grace Kelly, and to show historical collections from other institutions, as in the 2005 display *Style & Splendour: Queen Maud of Norway's Wardrobe 1896-1938*. Other shows followed, such as *Radical Fashion* (2001), *Vivienne Westwood* (2004), *Black British Style* (2004), *Spectres: When Fashion Turned Back* (2005) and *The Golden Age of Couture: Paris and London 1947-1957* (2007), and collaborations with contemporary designers as in *Hats: an anthology by Stephen Jones* (2009). Such exhibitions allowed the creative freedom to explore new ways of interpreting and displaying fashion.

The acquisition of large collections continues to be an important means of collecting fashion and textiles, just as it was in the nineteenth and twentieth centuries. The Michael and Gerlinde Costiff collection acquired in 2002 comprises 178 well-loved clubbing outfits by Vivienne Westwood, while specific pieces such as the Lucile gown 'Carresaute' of 1905 (pl.79) and a group of 1930s Vionnet gowns, acquired jointly with the Bowes Museum, and the Fashion Museum, Bath, help to fill gaps in the collection. Many outfits are acquired specifically for exhibitions, such as Christian Dior's gown 'Zemire', once thought lost, but identified and acquired for *The Golden Age of Couture* in 2007, and a Schiaparelli coat with trompe l'oeil embroidery designed by the artist Jean Cocteau and acquired for the exhibition *Surreal Things*, also in 2007. Frequently, donations from established or new designers such as Dries van Noten, Helmut Lang, Prada, Zac Posen and Giles arrive straight from the catwalk, ensuring the collection remains up to date (pls 104, 107, 130, 158).

The V&A's wider collections hold contextual material that provides essential information about the production and dissemination of fashion, from fashion plates, circulated around Europe in the eighteenth and nineteenth centuries to convey the latest styles, to the minutes of the meetings of the Incorporated Society of London Fashion Designers from 1949 to 1959. Important archives of French and British dressmakers, such as those of Charles Frederick Worth, the founder of haute couture in Paris in the 1870s, are also held in the V&A's Archive of Art & Design. Journals and magazines provide an overview of changing styles, season by season, such as *The Ladies Gazette of Fashion* (1842-94), which included the latest Paris styles. From the 1860s, some magazines included paper dress patterns, a new phenomenon that ensured the magazine's appeal among an increasing middle class. Twentieth-century archives of photographers such as Cecil Beaton and John French reflect the vital relationship between photography and fashion (pls 115, 128, 140).

The fashion collection is also enriched by a vast collection of related material such as designs on paper by Anna Maria Garthwaite for the eighteenth-century Spitalfields silk industry, nineteenth-century ribbon sample books, and textile swatches by twentieth-century designers such as Celia Birtwell and Zandra Rhodes that offer an insight into the creative relationship between textile and fashion design. Fashionably dressed dolls can also provide material evidence: a red-cheeked wooden doll dressed in a silk sack-back robe provides specific information about how dress was constructed between 1755 and 1760, down to the underwear, while a bisque head doll is clad in the fashionable bustle style of the 1880s. Her clothes were made by Mrs Latter Axton, a designer for the London department store Marshall & Snelgrove (pls 3, 7, 64).

Although the V&A collection is weighted towards womenswear because more has survived, displays such as *Men in Skirts* (2002) and the donation of an immaculate collection of designer menswear by Mark Reed in 2011, have helped to redress the balance. The Museum does however have much splendid court wear, such as a man's suit of the 1820s complete with linen stock and ceremonial dress sword, that arrived still packed in its original wooden storage box. 'Fancy' waistcoats abound, such as one made by the Spitalfields weavers Maze and Steer in 1788, but everyday menswear, being plainer, often well worn and in the past not thought worth preserving, is more of a rarity (pls 12, 13, 170, 171).

In the absence of actual garments, oil portraits such as *Man in a frock coat* (pl.19) provide useful visual evidence. Rather more exaggerated in their depiction of fashionable menswear are the eye-catching advertisements produced by tailors and outfitters in the nineteenth century, such as James Fougère, who was one of the first British retailers to label his garments. Couturiers, dressmakers and high-end department stores followed suit from the 1860s, in their use of woven and printed labels. Additional handwritten labels can often provide invaluable information: one in the bodice of Dior's 'Zemire' indicates that the client was Lady Sekers, wife of the innovative textile manufacturer Miki Sekers, from whose fabric the dress is made. One of the more modest items in the collection is an unused roll of woven silk labels by the Anglo-American couturier Charles James; the history of fashion often lies in the detail (pls 41, 109, 129).

The Fashion Gallery has long been one of the most popular in the Museum, and the collections have consistently provided an inspiration to designers: in 1924 the *London Evening Times* published an article called 'Dress Fashions – from the Museum!'. The director Cecil Smith was quoted as saying: 'One of my assistants believes that the reintroduction of the wide skirt was brought about by the creators coming here and studying . . . our costume exhibition.' Designers today continue to find inspiration in the Museum's collection, such as Vivienne Westwood who has spent many hours studying dress and painting in the V&A: 'I take something from the past that has a sort of vitality that has never been exploited – like the crinoline – and get very intense. In the end you do something original because you overlay your own ideas.'

Since 1962, the Museum has displayed fashion in the Octagon Court, a vast atrium with a spectacular domed ceiling designed by Sir Aston Webb in 1909. The refurbishment of the gallery in 2012 has revealed its original architectural grandeur and provided a dramatic new mezzanine space for fashion, with an inaugural exhibition, *Ballgowns: British Glamour Since 1950*, coinciding with a new display of the permanent collection which includes dress, textiles, jewellery, paintings, fashion plates and photographs. The Sandby Fresco, painted in 1793 as part of the dining room scheme for the demolished Drakelowe Hall, but now integrated in the Fashion Gallery, provides an atmospheric backdrop for a group of tailored outdoor riding and walking garments that exemplify the roots of British tailoring. Nearby stands a tailored ensemble by Savile Row-trained Alexander McQueen, reflecting the continuity of this tradition some 200 years later (pls 15, 16, 18, 179).

The V&A is exceptional among most museums in having the space and scope to provide a permanent public display of fashion as well as a programme of temporary displays and exhibitions. However, only a fraction of the fashion and textile collections are on display at any one time, owing to their fragility and sensitivity to light. The reserve collections provide further opportunities for study and are housed in The Clothworkers' Centre for Textiles and Fashion Study and Conservation, at Blythe House in Kensington Olympia. Here, cut and construction can be studied, or the works of a specific designer can be viewed; while Museum curators have tended to value complete outfits for display purposes, equally interesting are those partial or unfinished garments, such as a perfectly formed silk sleeve from 1830, temporarily detached from its dress, which allows close study of its construction, the swell of the form being dependent on an invisible feather-filled arm pad. Other objects become almost abstract, such as a lone bodice from the 1870s lacking the skirt that originally would have provided a counterbalance to its enormous sleeves (pl.35 and pl.74).

Common to all the Museum's displays over the decades is the mannequin, with its own sartorial history. Dressing a figure is a balance between conservation requirements and the drama of display. Mounting techniques, crucial to the authentic and safe display of historical dress, have become ever more sophisticated and creative. Recreating the right silhouette with underpinnings such as corsets and bustle cages, often based on patterns taken from similar examples in the V&A's collections, is a time-consuming occupation. While commercial mannequins provide the specificity for temporary exhibitions of contemporary fashions, museums have a tendency to return to the calico-covered dressmaker's form. Its timelessness and neutrality is undistracting, while the torso can be padded or reduced to fit each individual garment. The garment itself is never altered.

The V&A's original mission was to further 'instruction in art and science in relation to an industrial world', and the development of fashion design is often a product of technological progress, reflected in the Museum's collections. The bobbin net machine was patented in 1808 to copy hand-made net, offering a delicate ground for embellishment, as seen on a ball dress from 1820–25. The invention of the Jacquard loom in the early nineteenth century enabled weavers to produce copies of fashionable Kashmir shawls in increasingly complex designs, while the invention of spring steel made it possible to replace layers of heavy petticoats with liberating cage crinolines, allowing for greater comfort and flexibility. The development of aniline dyes in the 1850s added a bright new spectrum of colours such as mauve and magenta, resulting in startling garments such as a group of crinoline dresses from the 1860s (pls 5, 28, 54–7).

The invention of the domestic sewing machine in the 1850s revolutionized the production of clothing and made the latest fashions accessible to a growing middle class, while department store blouses were bought by the most fashionable. Even the humble press-stud had an impact. Utilized from the 1880s, it allowed for neat and efficient fastening of the multi-layered styles of the late nineteenth century, while in the early twentieth century, zips facilitated the development of close-fitting, sinuous styles made of silks, satins and new synthetics. In the last decades, laser cutting has allowed fashion to be produced in unprecedented quantities and digital printing has allowed for both a greater complexity and

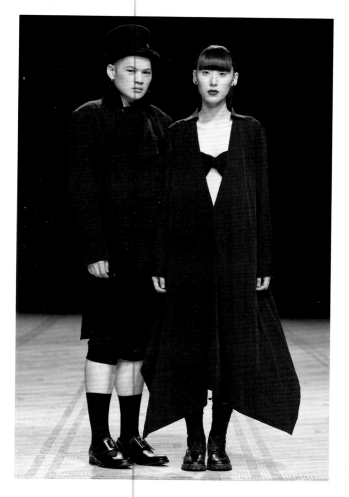
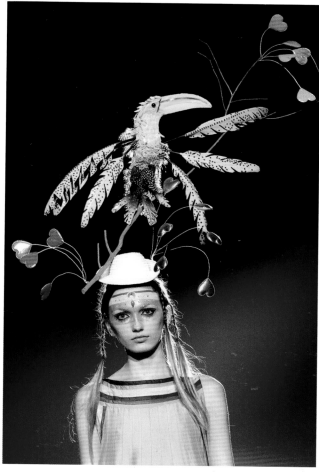

Fashion in Motion events at the V&A, featuring Yohji Yamamoto, 2011 (left) and Manish Arora, 2007 (right).

individualization of fashion; while the Museum acquired the ready-to-wear version of a digitally-printed dress from Alexander McQueen's Spring/Summer 2010 collection, for the haute couture versions each permutation of the print on the dresses was unique.

Fashion shows allow designers to present their vision in a controlled way before it is released to buyers, from hair to cosmetics, accessories to stance. Such concerns about both the need and desire to see contemporary clothing as it is intended to be worn led to the inception of live Fashion in Motion events in the Museum in 1999, with models wearing ensembles lent by designers. At first the processions snaked through the Museum's galleries, but now, to ever-increasing audiences, Fashion in Motion takes place on a catwalk amidst the sculptures and paintings of the Museum, and is streamed live on the V&A's website.

Henry Cole said that 'the aim of the Museum is fully to illustrate human taste and ingenuity'. Today, new developments in fashion studies have brought an interdisciplinary approach that embraces anthropology, psychology and cultural geography to add to the Museum's original preoccupation with design and industry. Visitors have an increasingly sophisticated knowledge of fashion, while new ways of accessing information on the Internet provides a global perspective. The way the Museum acquires fashion has also changed: international developments are tracked as they happen, while acquiring the work of contemporary designers helps the collection to develop and grow, and to reflect the enduring diversity and artistry of fashion.

Court
and
Country

Court fashion in the eighteenth century was characterized by the use of extravagant and exclusive textiles and lace. French silks were highly sought after until their import to Britain was banned in 1766. Designers and weavers in London also produced high-quality silks, their exquisite patterns often based on English flowers.

Printed cottons produced in England imitated the attractive hand-painted cottons imported from India. Their fast bright colours became increasingly popular as new technology made them more affordable.

Weavers in India also produced extremely fine white cotton muslin, which was sometimes embroidered specifically for the European market, and made into dresses in the fashionable neo-classical style. Luxurious pashmina goat hair shawls imported from Kashmir provided warmth and elegance.

Textile design (detail of pl.7)
1752

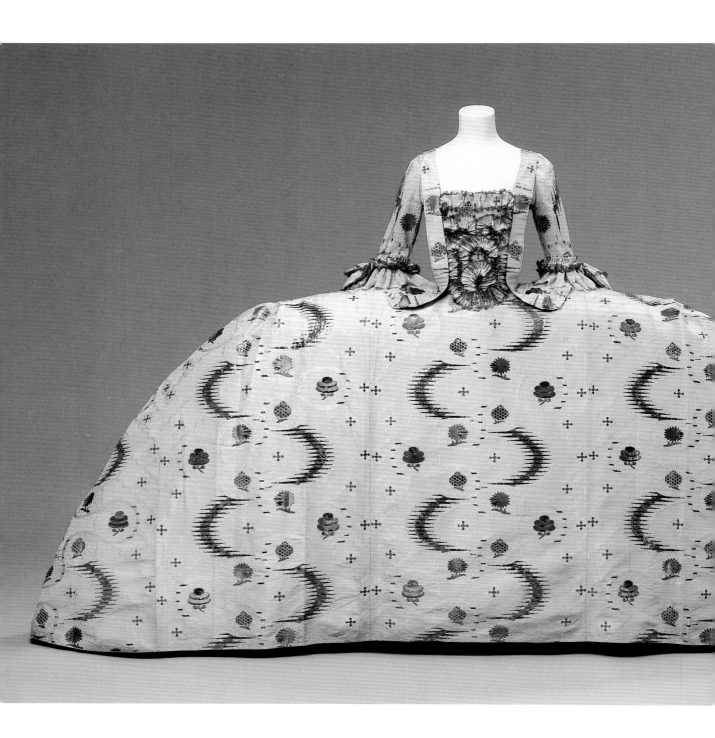

1. Mantua
1753–55

The mantua was among the most fashionable styles of gown in the early eighteenth century, consisting of a bodice and train worn over a petticoat of matching silk. By the 1750s, with its shape still dominated by the wide hoops going out of style in fashionable dress, it was worn only for attendance at court.

England
Silk brocaded with gilded silver thread

Given by the Crawley family
V&A: T.592:1,2 and 5 to 7–1993

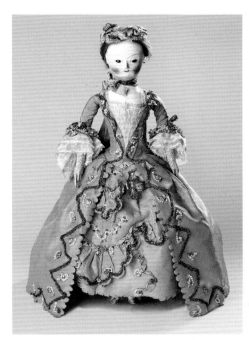

3. Doll
1755–60

This doll was probably not intended as a toy, although after serving its original purpose it may have been used for play. Before the general circulation of fashion plates, dolls were made to show the latest styles, and this one is dressed in a silk sack-back robe with all the accessories and underpinnings of a fashionable lady of the late 1750s.

England
Painted wood, with clothing of silk, linen and cotton

V&A: T.90 to V–1980

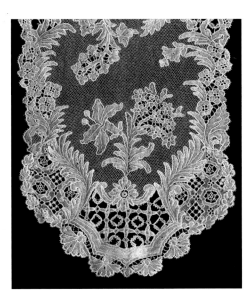

2. Lappet (detail)
1750–60

Brussels, Southern Netherlands
Needle lace on bobbin-made ground

Given by Margaret Jardine
V&A: T.107–1916

4. Dress (*robe à l'anglaise retroussée*) *c.*1775

England
Silk; shown with a replica petticoat

Given by Miss A. Maishman
V&A: T.96–1972

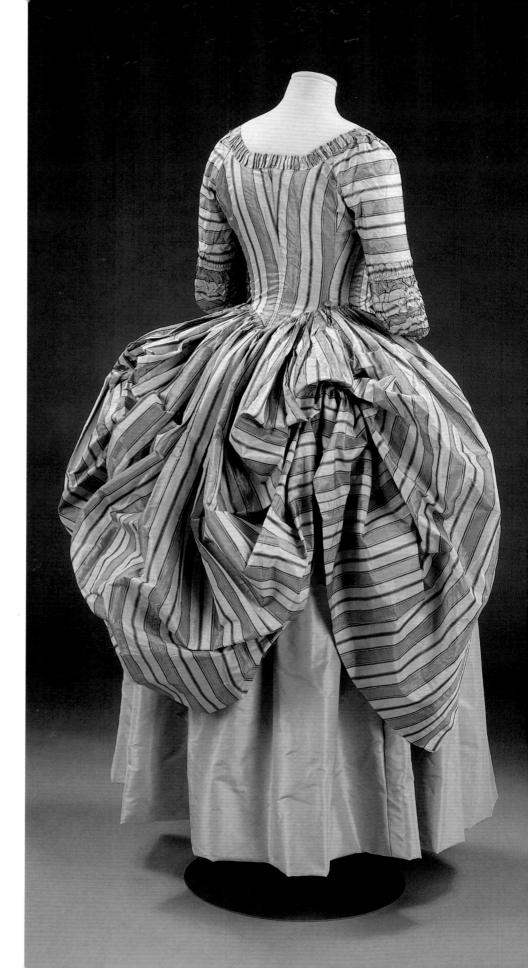

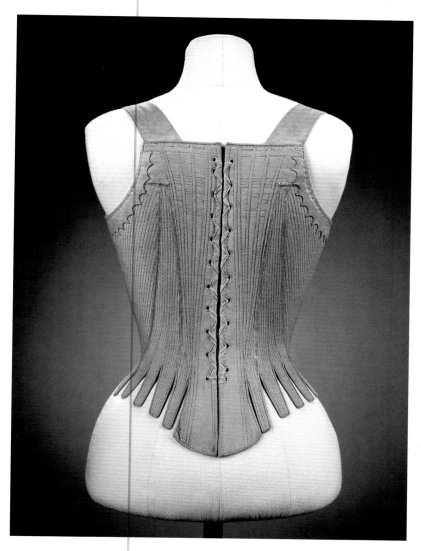

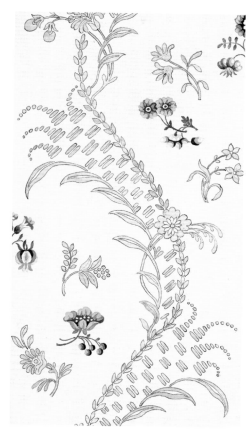

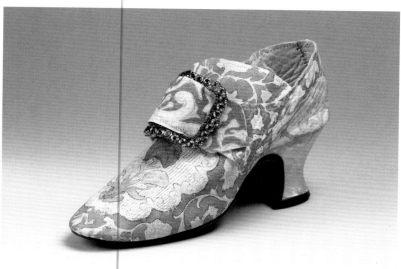

5. Stays
1780-90

England
Linen with leather, silk and whalebone

Given by Mrs Strachan
V&A: T.172–1914

6. Shoe and buckle
1760-70

Shoes: Brussels (possibly), Southern
Netherlands; painted leather
Buckle: England; silver and paste

Buckle given by the Rev. R. Brooke
V&A: 270–1891; 945A–1864

7. Textile design
Anna Maria Garthwaite (1690-1763)
1752

England
Watercolour on paper
V&A: 5989.9

8. Dress
1795–1800

This printed cotton design of floral trails shows a blend of influences from Indian painted and printed textiles, and European woven silks. Multi-coloured prints were time-consuming to produce, and more expensive than single colour designs, because a different carved wooden block was needed for each colour. Some details were added with a fine paintbrush.

England
Block-printed cotton
V&A: T.355–1980

9. Shawl (opposite)
*c.*1780

Kashmir, India
Goat hair (pashmina)
Given by Mrs M. Jacquet
V&A: IS.83–1988

shown on image with

Day dress
1800–08

Bengal and Britain
Embroidered cotton
Given by Miss Frances Vickers
V&A: 444–1888

10. Bag wig
1810–20

England
Horsehair and silk
V&A: T.106D-1953

11. Court coat and waistcoat
c.1800

Although court dress was the most formal
style of dress, by 1800 it was not the most
fashionable. Such rich fabrics and embroidery
were no longer worn for everyday wear,
but the requirements of court dress provided
work for craftspeople in the textile industries.
The suit is thought to have belonged to a
Scottish nobleman and ancestor of the donor.

England or Scotland
Silk velvet embroidered with chenille
and silk thread

Associated with the Tweedale family
Given by Lady Caroline Tyrell
V&A: T.111&A-1985

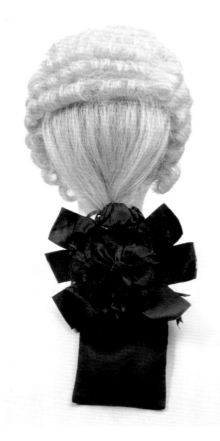

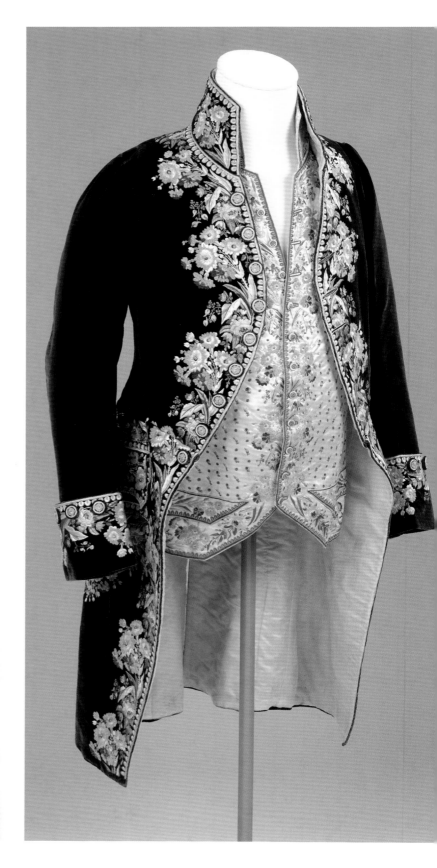

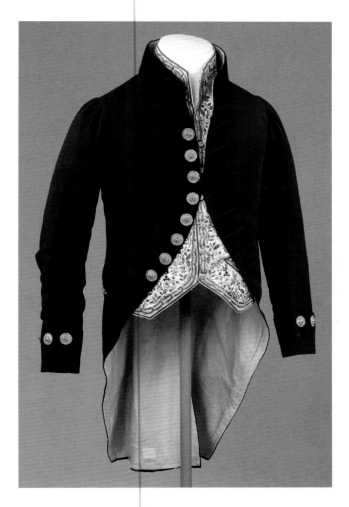

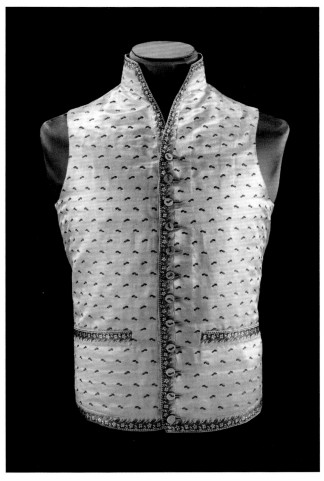

12. Court coat and waistcoat
1810–20

England
Coat: wool with cut and polished steel buttons
with faceted steel rivets
Waistcoat: embroidered silk
V&A: T.106&B–1953

13. Waistcoat
1788

The silk for this waistcoat appears in three different colourways
in Spitalfields weavers Maze and Steer's 1788 pattern book
labelled 'Fancy Vestings and Handkerchief Goods'. The front
parts of the waistcoat would have a linen back attached,
which allowed the garment to be tailored to an individual
customer's size.

London
Silk, woven by Maze and Steer
Given by A.M. Talbot
V&A: T.89–1924

Taking the Air

1790
—1830

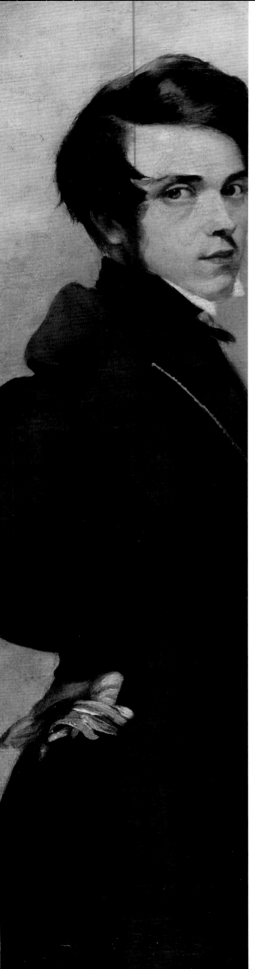

The British aristocracy spent a large part of the year at their country estates. Practical garments were needed for hunting and other outdoor activities: plain wool coats, woollen waistcoats, and wool or leather breeches worn with boots. By the end of the eighteenth century, this characteristically British style was also fashionable in Paris.

British tailors were known for their skill in cutting cloth to show off a man's figure to full advantage, emphasizing symmetry and proportion. In the early nineteenth century many tailoring manuals were published, with new measuring systems to improve cutting, and the first tape measure for general use had appeared by 1818.

The same tailors made women's riding coats or 'redingotes'. Dressmakers then reinterpreted these garments for women to wear for travelling, walking and visiting.

Man in a frock coat (detail of pl.19)
*c.*1830

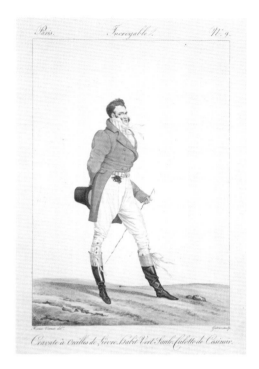

**14. Fashion plate 'Incroyable No.9'
Horace Vernet (1789–1863), Georges
Jacques Gatine (b.1768) (engraver)
1814**

Paris
Engraving coloured by hand
V&A: E.127–1947

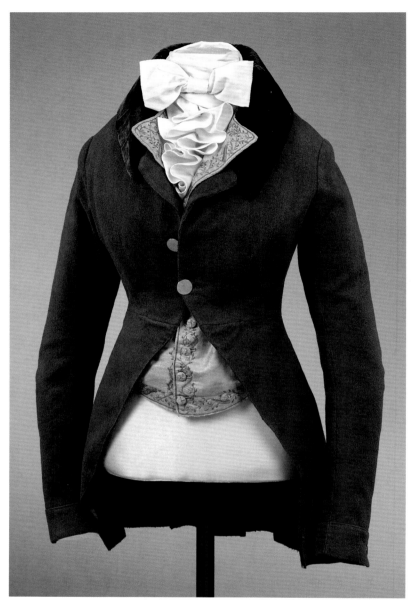

**15. Riding coat and waistcoat
c.1790**

Dark wool riding habits were fashionable from the 1780s and were often green,
navy or red, depending on which hunt was followed. Women would have worn
jackets such as this, with a silk plush hat, waistcoat and full skirt, for a range of
outdoor activities including travelling and walking, and sometimes as everyday
morning dress.

England
Coat: wool with gilt metal buttons
Waistcoat: embroidered silk

Given by Harrods
V&A: T.670&B–1913

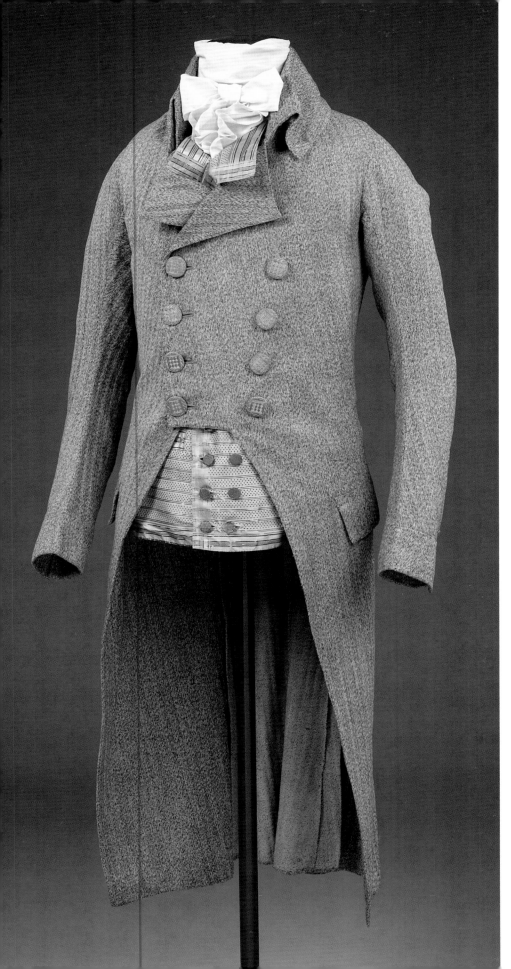

16. Coat and waistcoat
c.1790

By the 1790s, the gentleman's frock coat had been adapted for fashionable day wear. This smart coat is made in an unusual flecked grey wool with large, silk-covered buttons. The standing collar, high waist, wide lapels and tight sleeves suggest the exaggerated styles worn in revolutionary France.

England
Coat: wool with buttons covered with silk thread
Waistcoat: printed silk

Given by A.M. Talbot
V&A: T.281–1991; T.88–1924

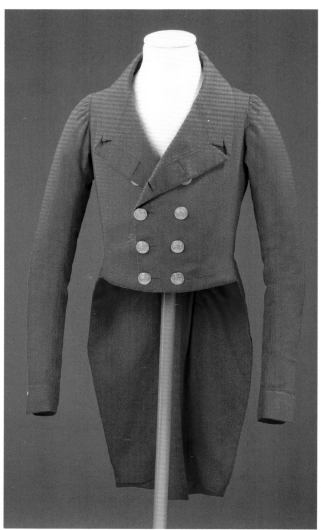

17. Hunting coat
1810–20

England
Wool with gilt metal buttons

Purchased with the assistance
of The Art Fund, the Friends
of the V&A, and a number of
private donors
V&A: T.100–2003

18. Tailcoat, waistcoat and under-waistcoat
1815–20

England
Tailcoat: wool with gilt metal buttons
Waistcoat: silk
Under-waistcoat: cotton

Tailcoat given by Lady Osborn; waistcoat by G.J. Lamb;
under-waistcoat by Miss E.M. Coulson
V&A: T.118–1953; T.51–1958; T.153–1931

19. Man in a frock coat (opposite)
c.1830

France
Oil on card

Bequeathed by Claude D. Rotch
V&A: P.44–1962

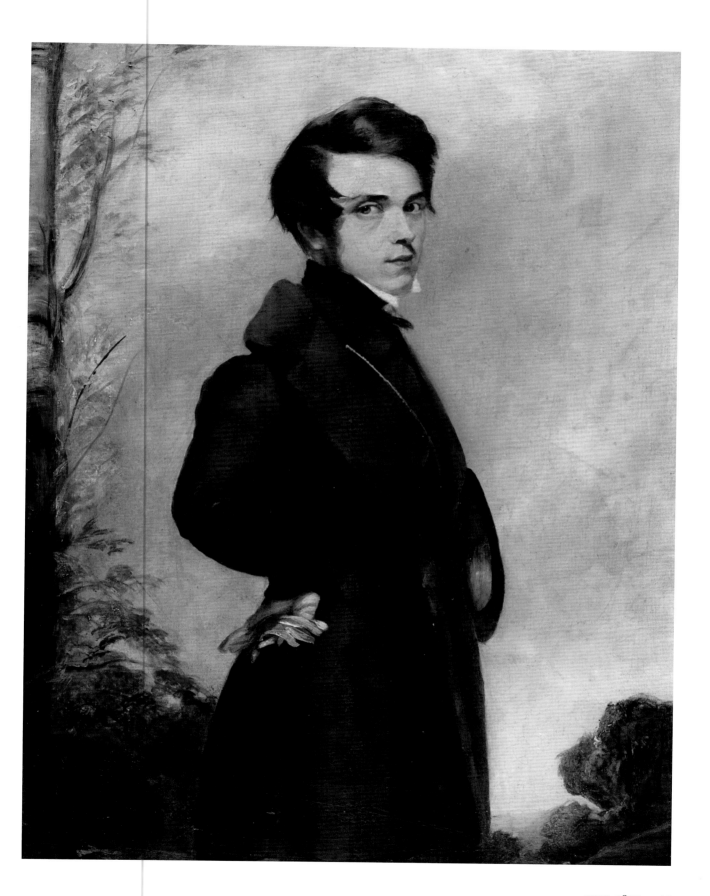

20. Walking dress (spencer, skirt and bodice)
1817–20

The elaborate uniforms of the Napoleonic Wars (1793–1815) inspired stylish trimmings on fashionable women's dress. Here, curved appliquéd satin bands and silk-covered passementerie emulate the frogging, braid and tassels of regimental jackets.

England
Silk with silk satin appliqué, silk frogging, tassels and braid

Given by Mrs A. Wallinger
V&A: T.110&B–1969

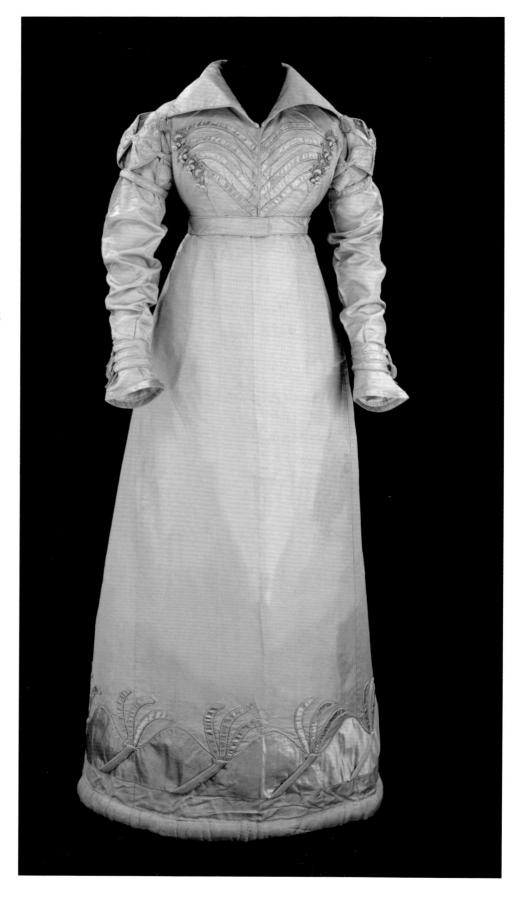

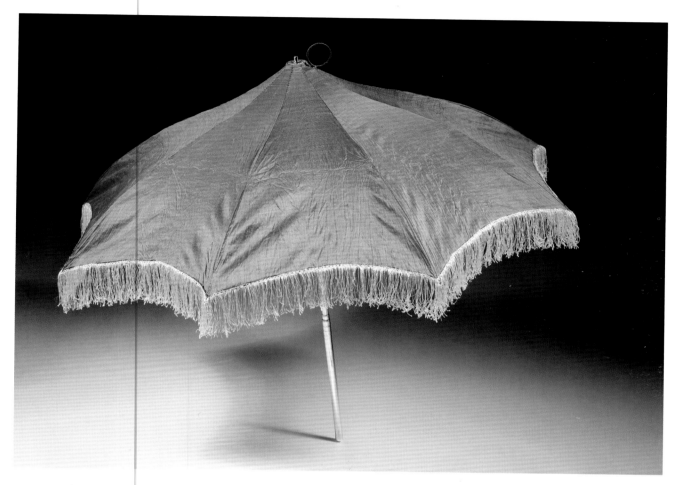

21. Parasol
Thomas Weeks (parasol) and
George Creak (silver handle)
1810–11

England
Silk, silver and steel

Sold at Weeks's Royal Mechanical
Museum, Tichborne Street, London
Given by Mrs Coral Samuel CBE
V&A: T.4-1987

22. Boots
*c.*1815

England
Leather

Worn by Mrs Norman (d.1821)
and given by the Misses Montefiore
V&A: T.108&A-1919

In
Society

1810
–1830

High-waisted styles remained popular for the first part of the nineteenth century. Evening dresses in the 1820s were often made of coloured silk or the newly invented machine-made net. Dresses for grand occasions incorporated trimmings of gold tinsel, embroidery and appliqué, emphasizing the bodice and widening skirt hem.

Much importance was attached to accessories, such as delicate carved or painted fans. Hats and bonnets became larger, and were decorated with artificial flowers and feathers, and hairstyles grew higher and were increasingly elaborate. The difficulty of arranging the hair may explain the popularity of caps for both formal and informal occasions, sometimes made to suggest the shape of a turban.

Fan (detail of pl.25)
1820-30

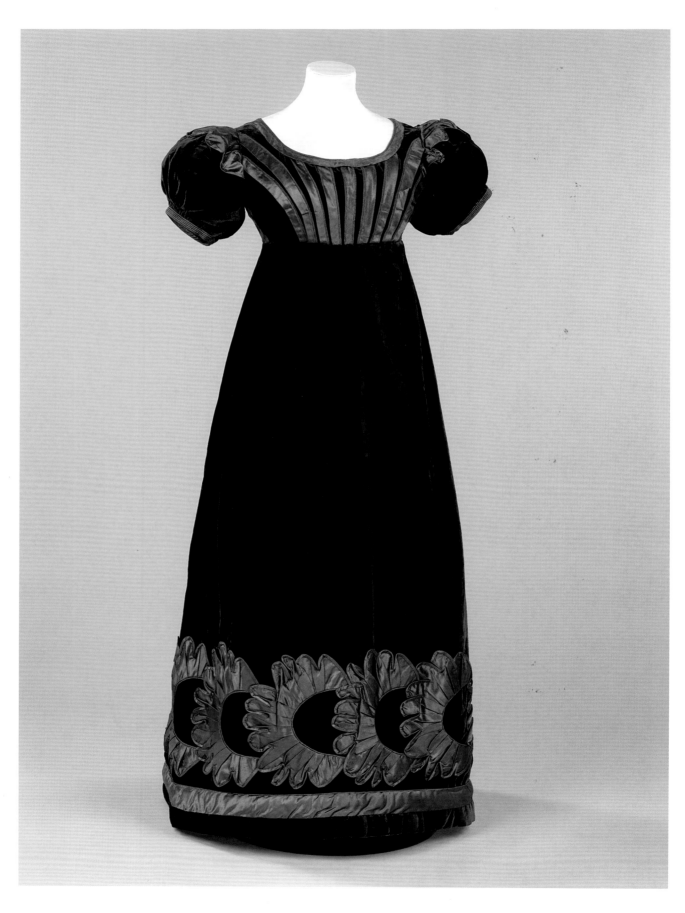

23. Evening dress (opposite)
1823–5

In times of national or private mourning, fashionable etiquette required men and women to transform their wardrobes with plain garments of matt wool or dull silk crepe. After a few months, black satin or velvet was permissible. According to family tradition, Jane Johnstone is believed to have worn this dress while in mourning for her grandmother.

Scotland or England
Silk velvet with silk satin piping and appliqué
Probably worn by Jane Johnstone (1803–47)
Given by Amelia McIlroy
V&A: T.73-2010

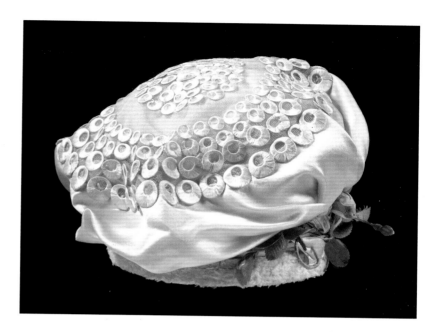

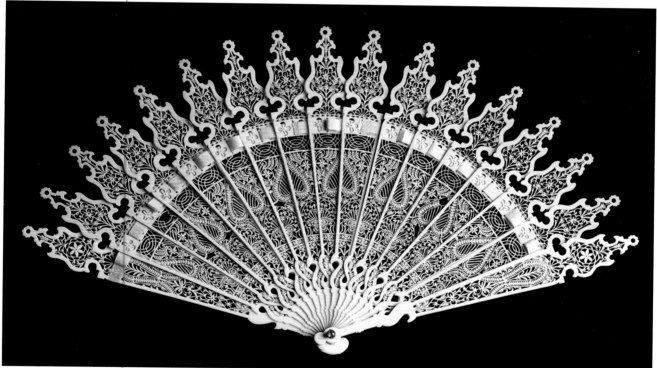

24. Cap
1820–25

England
Silk and net embroidered with silk thread; wired paper and muslin artificial flowers
Given by Henry Curtis
V&A: T.261-1926

25. Fan
1820–30

France
Pierced ivory
Given by Sir Matthew Digby Wyatt and Lady Wyatt
V&A: 2282-1876

**26. Fashion plate from *Costume Parisien*
1825**

Paris
Hand-coloured etching on paper
V&A: E.1156–1974

27. Fan (below)
1820–30

England or France
Horn sticks, gouache and metal
Given by Admiral Sir Robert
and Lady Prendergast
V&A: T.71–1956

28. Ball dress (opposite)
1820–25

England
Silk satin and silk net, embroidered with metal
and trimmed with silk blonde bobbin lace
V&A: T.196–1975

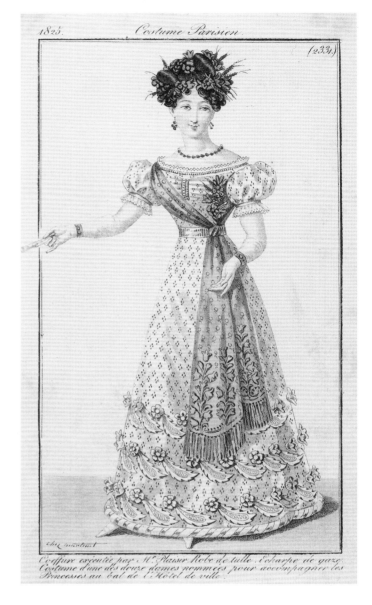

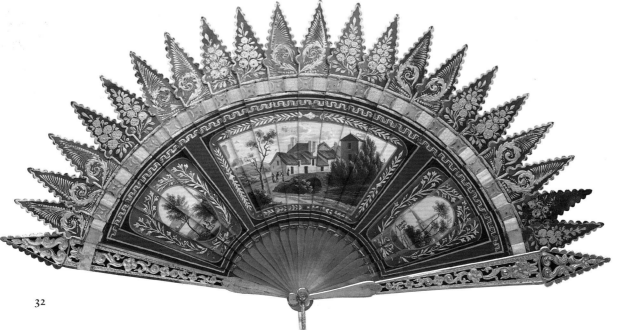

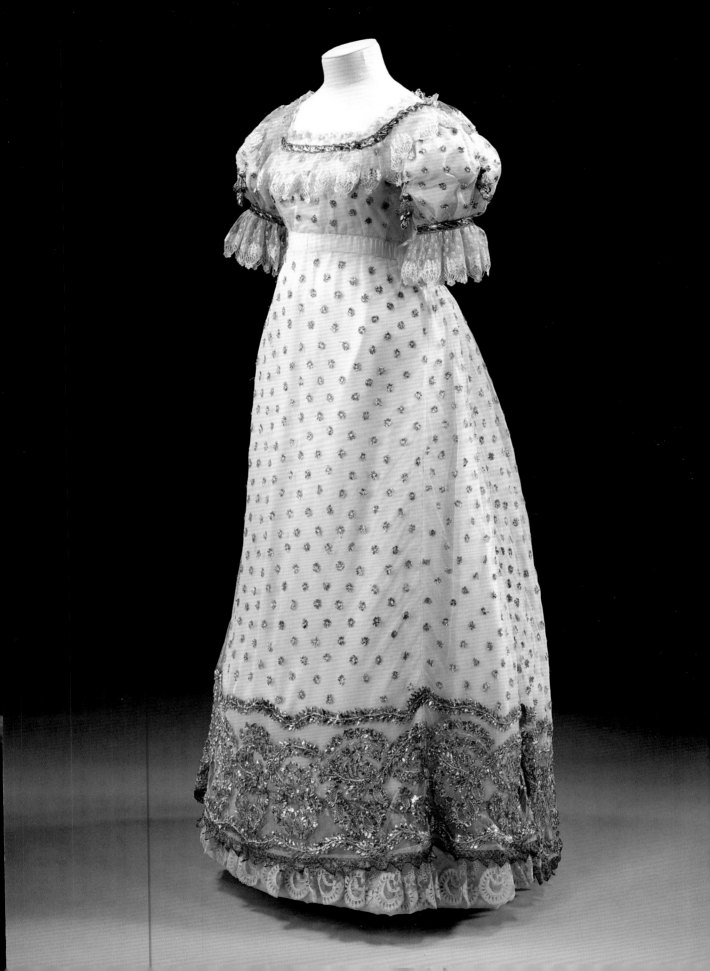

At Home

1825 −1840

Developments in the textile industry continued to influence fashion. The Jacquard loom reduced labour costs and increased productivity. Innovation in the dyeing and fabric printing industry increased choice for women and speeded up the pace of change.

As the price of fabrics decreased, dressmaking became more adventurous. Women's dresses became increasingly voluminous, with balloon-like sleeves in a variety of shapes. Petticoats stiffened with cord or horsehair and feather-filled sleeve supports were used to create the correct silhouette.

Collars and modesty fronts with fine white-work embroidery were very popular. Many of these were produced by highly skilled outworkers in Glasgow and West Scotland, who also made exquisite baby caps and gowns. Retailers sold cotton printed with designs for the home embroiderer.

Shawl (detail of pl.29)
1830–33

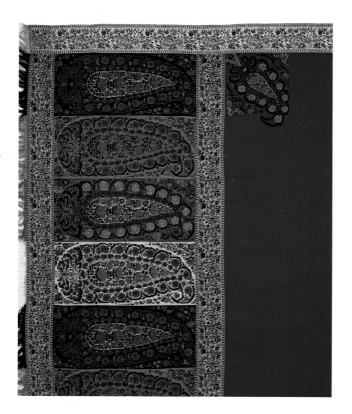

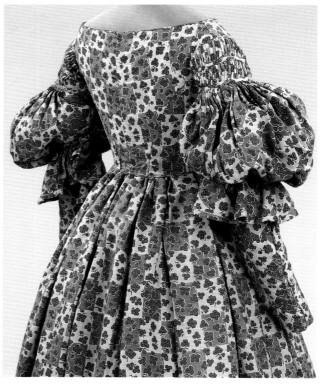

29. Shawl (detail)
1830–33

Imported Kashmir shawls could take years to weave and
were extremely costly status symbols in fashionable society.
Entrepreneurs in the British weaving industry produced
imitations that could be made in a week and sold for a tenth of
the price. Printed shawls were also widely available.

Edinburgh, Paisley or Norwich
Woven in silk, wool and cotton on a silk ground

V&A: 1156–1893

30. Day dress
1835–8

Women enjoyed an increasing choice of printed fabrics.
Semi-abstract patterns and softer floral trails were popular,
and the new delaine fabric enabled calico printers to offer
deeper and more brilliant colours. The bold designs were shown
off to great effect by the full sleeves and skirts of the 1830s.

England
Printed delaine (worsted wool and cotton)

Given by Mrs H.M. Shepherd
V&A: T.11–1935

31. Day dress (opposite)
1837–40

England
Printed challis (wool and silk)

Given by Miss E. Tucker
V&A: T.184–1931

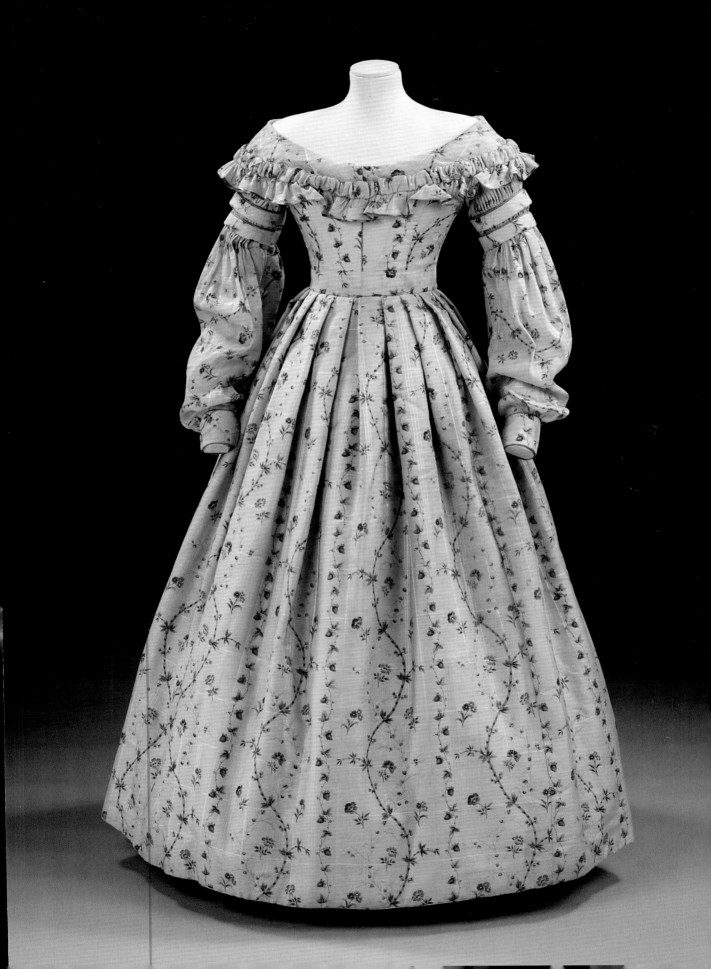

32. Dress
c.1835

England
Silk

Given by Miss Torey
V&A: T.60–1957

shown on image with

Modesty front
1830–35

The deeply cut neckline of this plain yet elegant silk dress required a contrasting embroidered, washable modesty front.

Great Britain, possibly Ayrshire, Scotland
Embroidered cotton

Given by Mrs C.E. Johnson
V&A: T.45–1967

33. Shoes
1830–35

England
Silk satin, kid leather and linen

Given by Thomas W. Grieg (top), C.M. Buckley (middle), Harrods (bottom)
V&A: 2218–1899, T.178–1962, T.503–1913

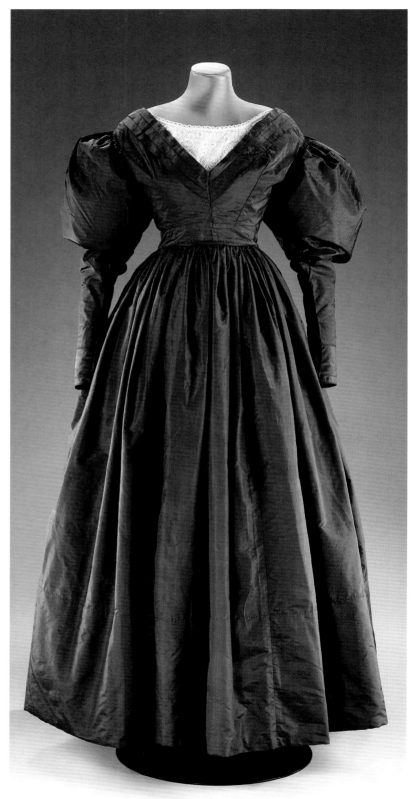

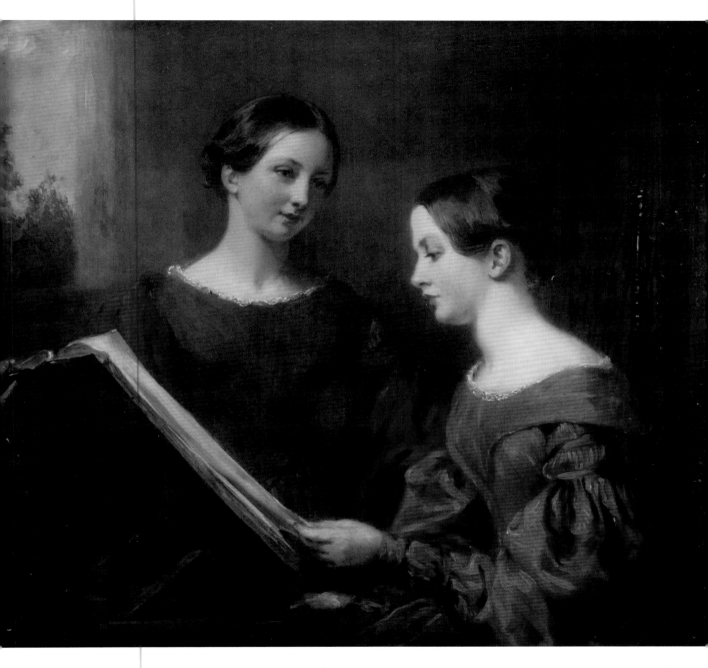

34. *The Sisters*
Margaret Sarah Carpenter (1793–1872)
1839

England
Oil on panel

Given by John Sheepshanks, 1857
V&A: FA.18[o]

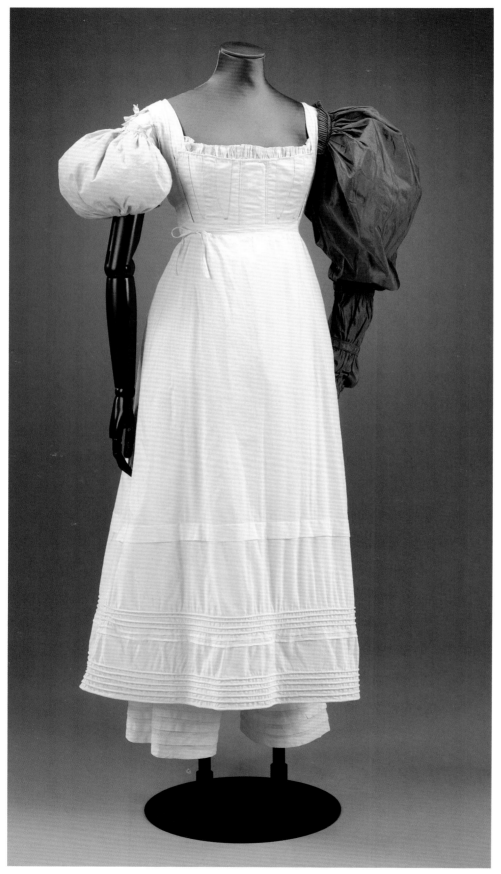

35. Underwear group

Chemise
***c*.1835**

England
Linen trimmed with cotton
Given by Miss Blake
V&A: T.386–1960

Drawers
1834

England
Cotton
Given by Mrs J.A. Latter Axton
V&A: T.102–1931

Corset
***c*.1830**

England
Cotton with whalebone
and cord
Given by Mrs Elizabeth Norton
V&A: T.3–1929

Sleeve supports
1825–30

England
Cotton filled with feathers
Given by Miss Frances E. White
V&A: T.189C, D–1921

Dress sleeve
***c*.1830**

England
Silk
V&A: T.157E–1979

**Petticoat with
shoulder straps**
1820–30

England
Cotton
Given by the family of
Mrs Jane Robinson
V&A: T.194–1929

36. Chemise (detail, as seen on pl.35)
*c.*1835

The chemise or shift had been an essential element of underwear for centuries, and remained so in the nineteenth century. It was worn next to the skin, beneath the corset and layers of petticoats. This knee-length, voluminous chemise of finely woven linen is trimmed with a cotton frill at the neckline, which is tightened with a drawstring.

England
Linen trimmed with cotton

Given by Miss Blake
V&A: T.386–1960

37. Corset
1825–35

Cotton, embroidered with silk thread, with cord inserts and trapunto quilting

V&A: T.57–1948

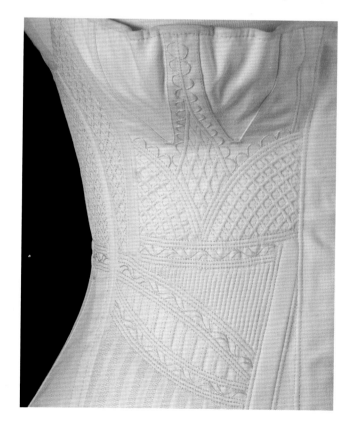

The
Male
Wardrobe

1840
–1875

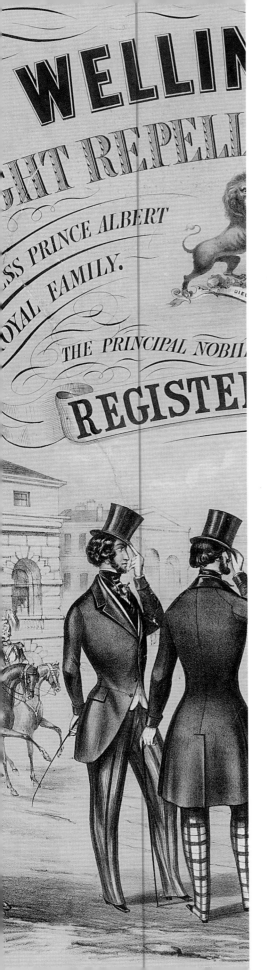

As women's dress became increasingly elaborate, so men's formal clothing became dark and plain. A gentleman could, however, display his individuality and taste with a brightly patterned 'fancy' waistcoat, either bought from an outfitter or hand-embroidered by his wife or daughter.

But fashion was no longer the prerogative of the upper classes. With the expansion of the ready-made tailoring trade, many more men could buy stylish clothes at competitive prices. City workers attempting to achieve gentility through dress were known as 'gents' or 'swells'. They wore frock coats and high cravats accompanied by carefully chosen accessories, such as top hats and canes.

Poster, *The Wellington Surtout* (detail of pl.41)
*c.*1845

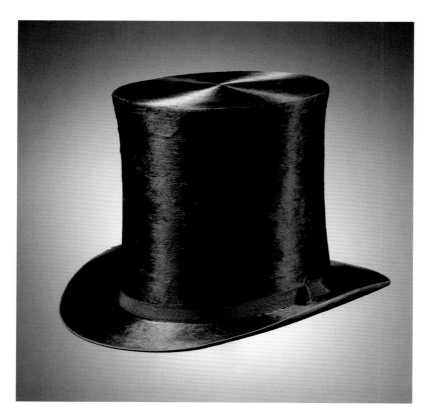

38. Top hat
Messrs Chapman & Moore
c.1855

Top hats made in a variety of shapes and sizes were worn throughout the nineteenth century. New manufacturing techniques developed in the 1830s reduced the cost of silk hats, enabling men from a much broader social spectrum to buy them. There was also a thriving second-hand market in re-covered hats.

England
Silk plush

Given by Mr Hubert Arthur Druce
V&A: T.19–1918

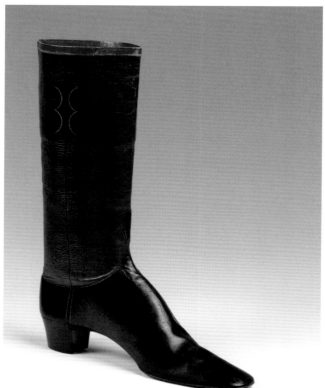

39. Boot
c.1850

London
Leather with wooden last

Given by Messrs Faulkner
& Son
V&A: T.427–1920

40. Fashion plate (opposite)
1 October 1842

France
Hand-coloured etching
on paper

V&A: Circ.375–1960

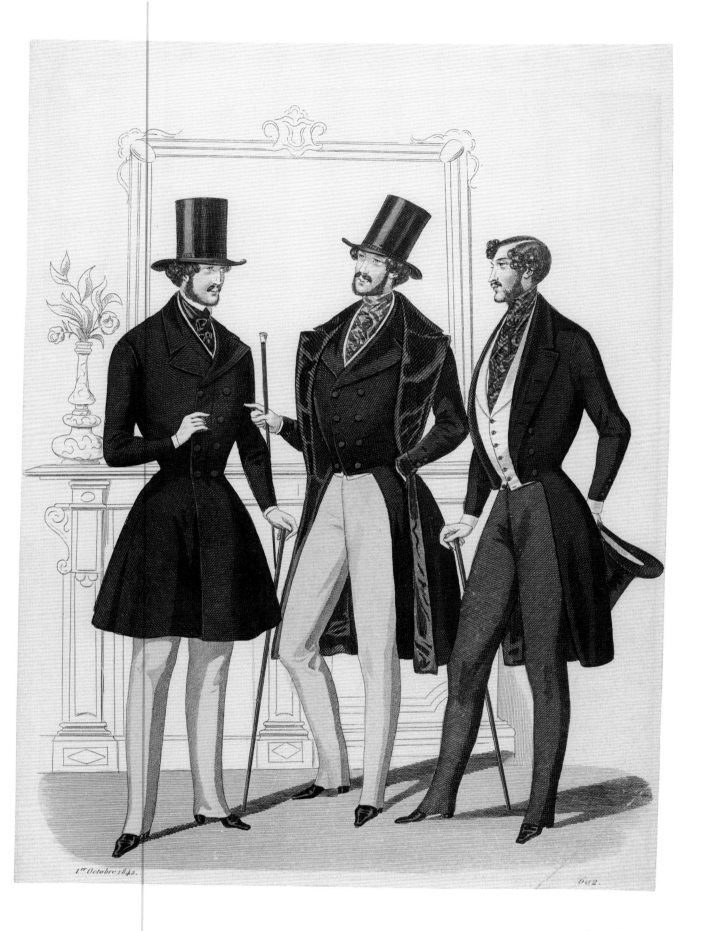

1.ᵉʳ Octobre 1842.

602.

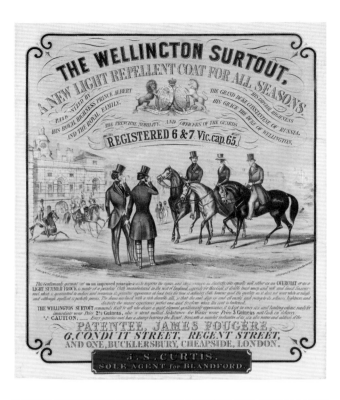

41. Poster, *The Wellington Surtout*
F. Sexton
c.1845

Tailors and outfitters selling ready-made menswear vied for customers through the use of eye-catching advertisements, flyers and brochures. Some, like James Fougère, the creator of the Wellington Surtout, registered their designs under the 1839 Design Copyright Act to protect their products from imitation. Fougère also marked his garments with his name and address to guarantee their authenticity.

London
Tinted lithograph
Printed by W. Dix
V&A: E.196–2010

42. **Waistcoat** (left)
1845–50

England
Jacquard-woven silk
Given by Mr H. Arnold Ovenden
V&A: T.1–1954

43. **Waistcoat** (right)
1845–55

England
Jacquard-woven silk
Given by Miss W. Shaw
V&A: T.10–1951

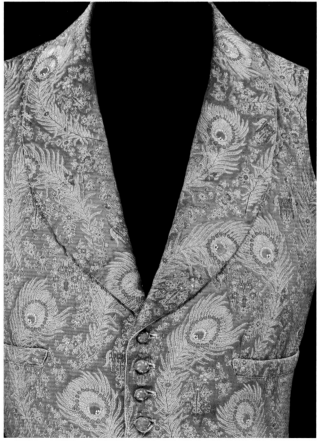

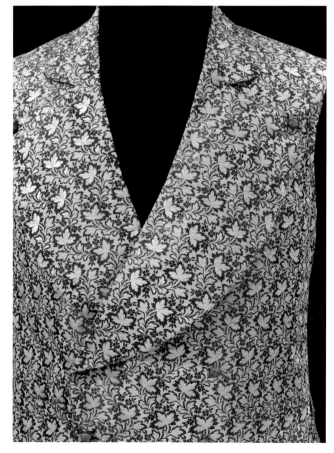

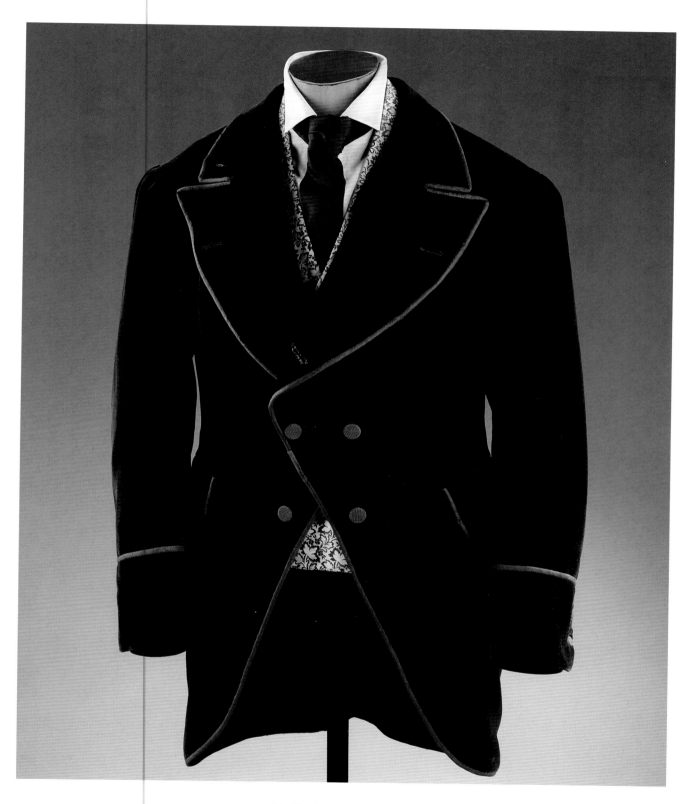

44. Coat
1873–5

England
Cotton velveteen lined with silk, wool twill and cotton
V&A: T.3–1982

The White Wedding

1840
–1860

By the 1840s it was customary for a well-to-do bride to wear white silk or fine white muslin. Lace wedding veils were a way of demonstrating status because of their cost and were often handed down in the family. Fragile wax orange blossom became popular as a trimming for headdresses and bodices.

Many mid-nineteenth-century dresses were later altered in response to changing fashions, but wedding dresses tended to be preserved unchanged. The most common male wedding garments to survive are silk waistcoats. Some are hand-embroidered, while others incorporate silver-coloured thread; like white, this was associated with purity.

Waistcoat (detail of pl.46)
1844

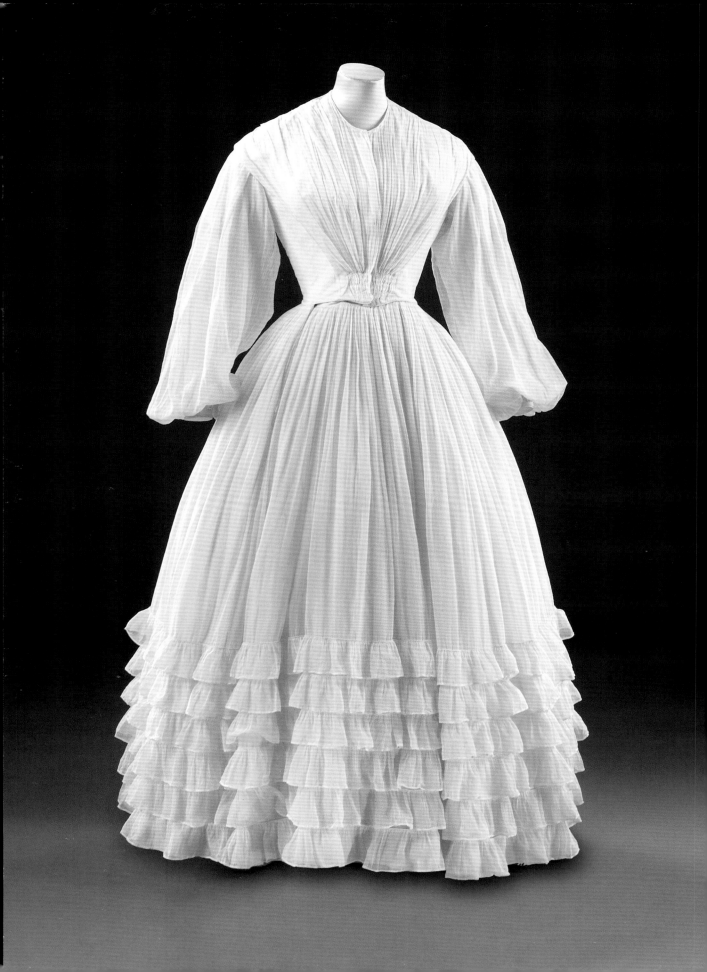

45. Wedding dress (opposite)
*c.*1851

England
Cotton muslin lined with linen and trimmed with bobbin lace

This wedding dress is linked to the marriage of Eliza Sneath to Joseph Candlin, Sheffield, 1851
Given by Mrs Bessie Miller
V&A: T.367&A–1988

46. Waistcoat
1844

England
Embroidered silk

Embroidered by Julia Norman for her husband John Montefiore
Given by the Misses Montefiore in memory of the late John Montefiore
V&A: T.699–1919

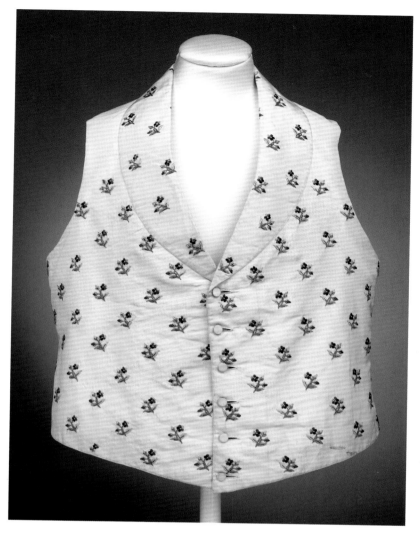

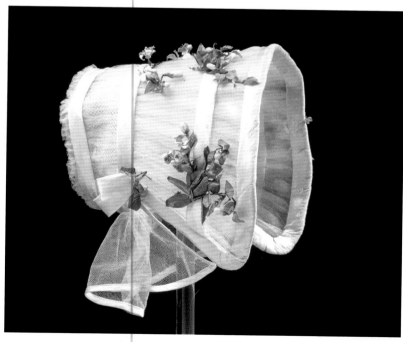

47. Wedding bonnet
1845

England
Silk tulle over a wire frame with silk crepe, wax and paper orange blossom

Given by Miss H. Blanche Buckley
V&A: T.69–1929

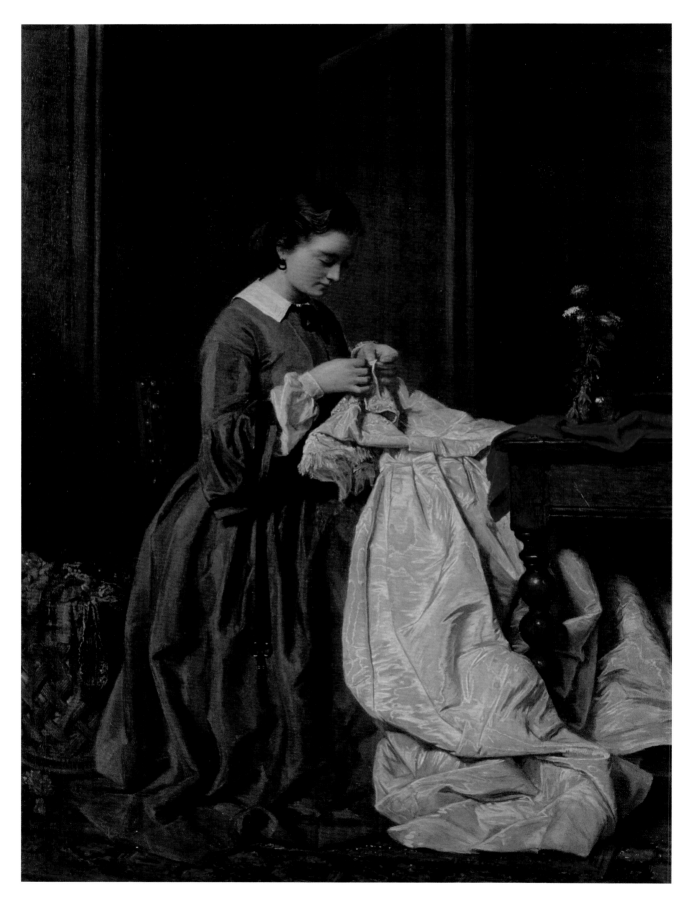

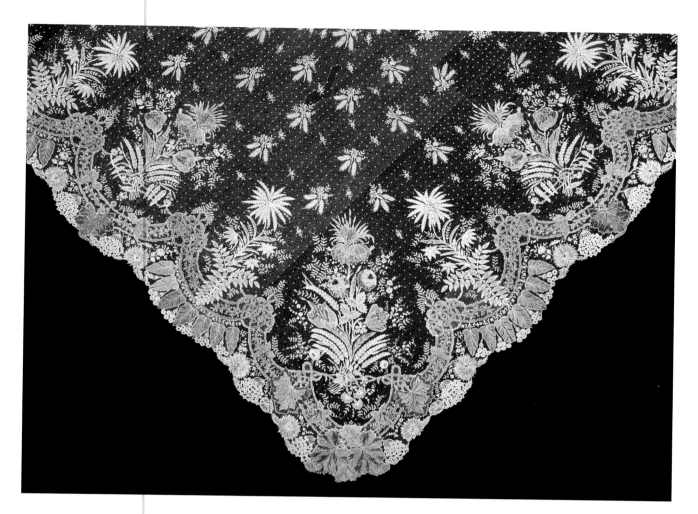

48. *The Seamstress* (opposite)
Charles Baugniet (1814–86)
1858

This painting uses dress and textiles to highlight the contrast between the life of a seamstress or lady's maid and her wealthy employer. Both dressmakers and servants worked long hours for low wages; the poor working conditions of dressmakers were well publicized and a cause for public concern throughout the nineteenth century.

London
Oil on panel
Bequeathed by Rev. Chauncey Hare Townshend
V&A: 1564–1869

49. Wedding veil
1850–60

Brussels
Needle and bobbin lace
Given by Mrs R. Marchard and Mrs Aronson
V&A: T.739–1974

50. Wedding favour
1889

Britain
Wax, cloth, paper and silk
Given by Mrs V.I. Lewin
V&A: T.266A–1971

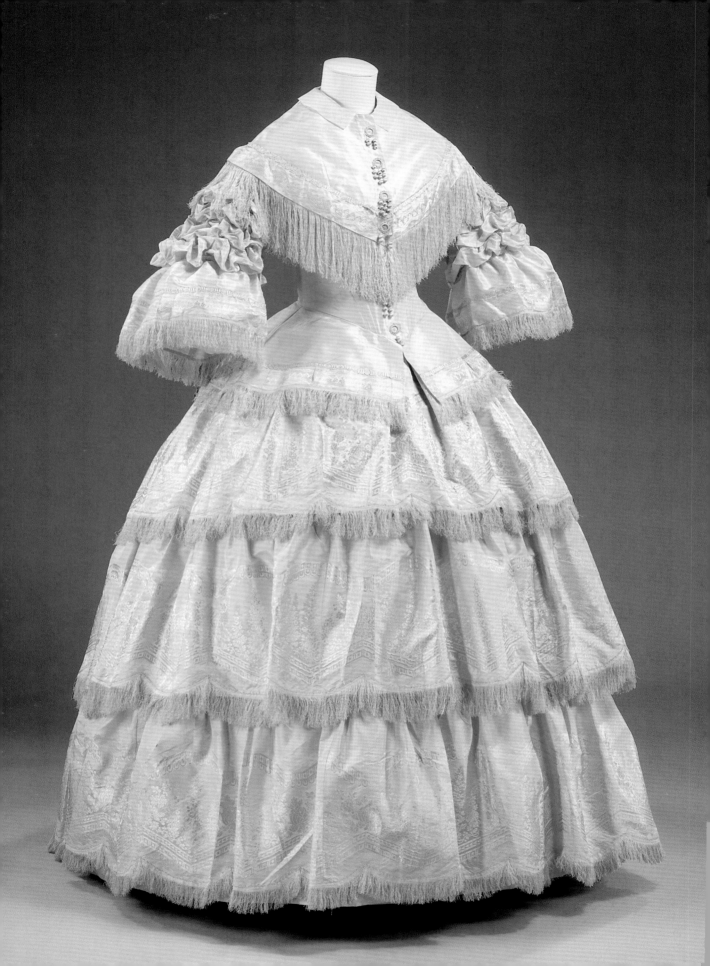

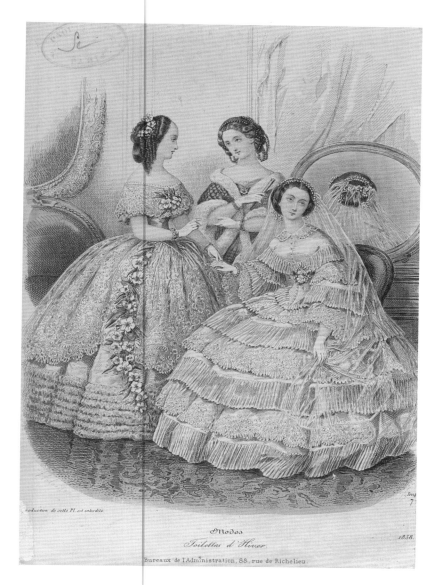

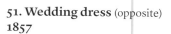

52. Fashion plate 'Toilettes d'Hiver' from *Journal des Jeunes Personnes* 1858

Paris
Hand-coloured etching on paper

Given by the House of Worth
V&A: E.22396[327]–1957

53. Shoes
*c.*1840

England
Silk satin, linen and leather

Given by Thomas W. Grieg
V&A: 2218&A–1899

51. Wedding dress (opposite)
1857

England
Figured silk trimmed with silk fringe

Given by the Misses I. & N. Turner
V&A: T.10 to C–1970

Fashion and Industry

1850 –1870

In the middle of the nineteenth century the fashionable silhouette reached extreme proportions. Corsets provided support and enhanced small waists, emphasizing the extraordinary size of crinoline skirts. New front-fastening corsets allowed for easy dressing, while metal fittings and eyelets meant that laces could be pulled tighter. Voluminous, semi-fitted mantles and capes were needed for outerwear; these were among the first garments to be available off-the-peg.

Hand-tinted fashion plates in magazines enabled women to keep up to date with the latest styles from Paris, where fashions were set by Empress Eugenie (wife of Napoleon III) and her couturiers. Hairstyles echoed the domed curves of the crinoline, and volume was added with hairpieces. Small bonnets and caps were worn, framing the face, while tightly fitting gloves and slender shoes gave the appearance of fashionably tiny hands and feet.

Bodice (detail of pl.62)
*c.*1865

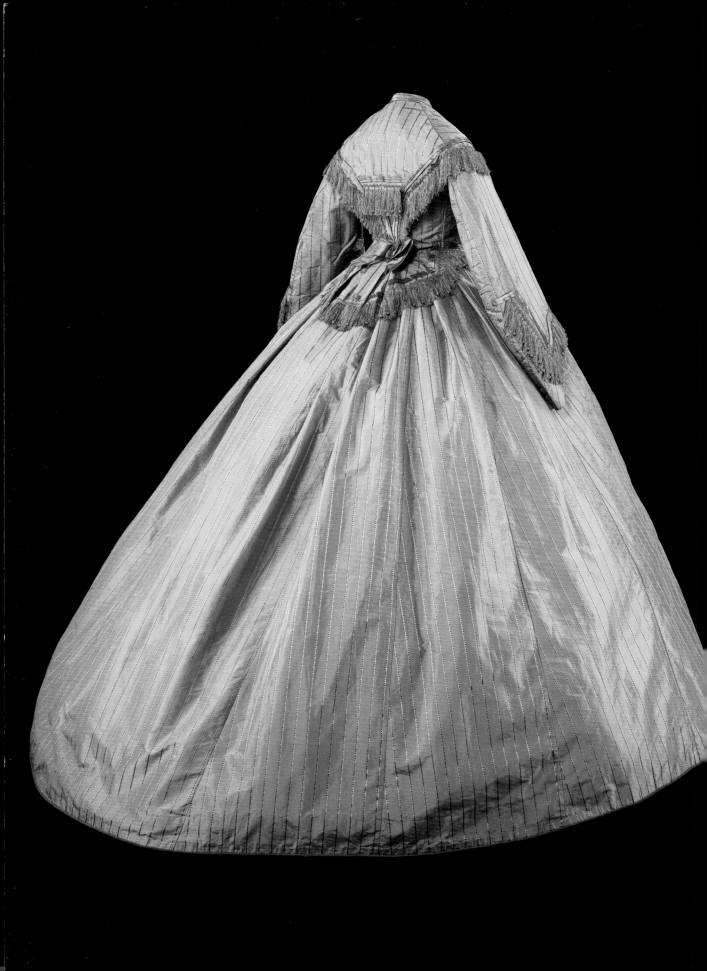

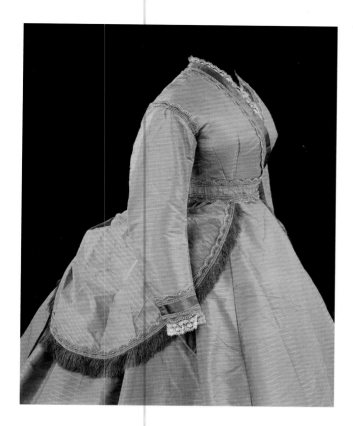

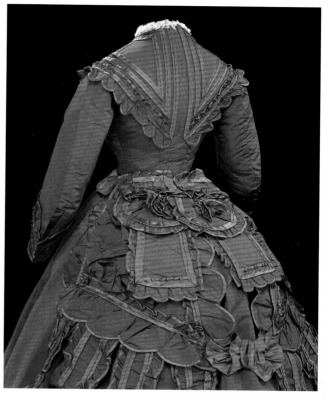

54. Dress (bodice and skirt) (opposite)
1862

The silk of the dress is dyed with aniline blue, formulated in 1860 by two Parisian scientists working at Brentford, near London. Aniline blue became instantly popular as, unlike indigo-based bright blue dyes, it did not appear green in gas-light. Isabella Bowhill (1840–1920), the donor's grandmother, is said to have worn this dress on a visit to London's International Exhibition of 1862.

England
Jacquard-woven silk trimmed with silk satin

Given by Miss I. Bowhill McClure
V&A: T.2&A–1984

55. Dress (bodice and skirt) (above, left)
1868

England
Silk trimmed with silk fringe, braid and satin with glass beads and hand-made Maltese-style bobbin lace

V&A: T.37 to C–1984

56. Dress (bodice, skirt and peplum) (above, right)
Monsieur Vignon (active 1860s–1880s)
1869–70

Paris
Ribbed silk trimmed with satin, lined with silk and whalebone strips

V&A: T.118&A to C–1979

57. Cage crinoline
1860–65

Britain (probably)
Spring steel frame covered with linen and woven red wool

The waistband is stamped with the words 'A FAVOURITE OF THE EMPRESS'
and refers to Empress Eugenie of France
Given by Mrs A.E. Valdez
V&A: T.150–1986

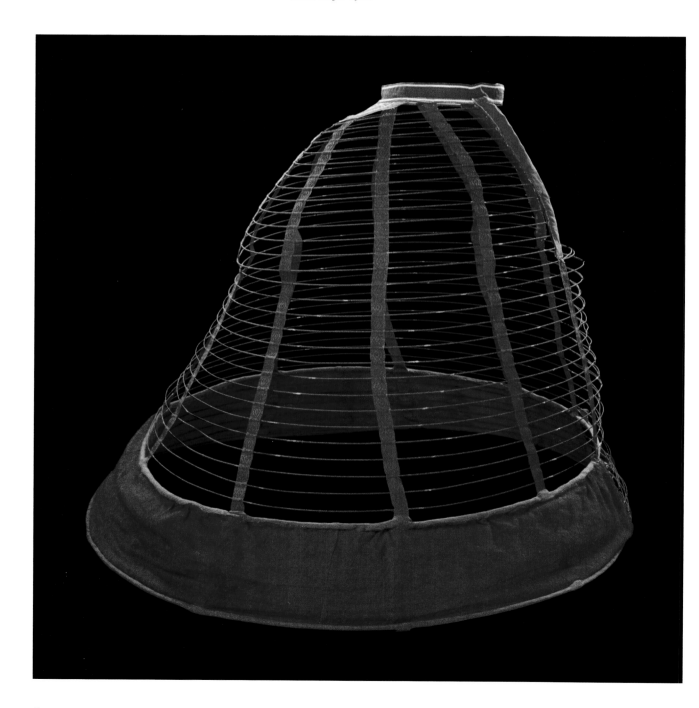

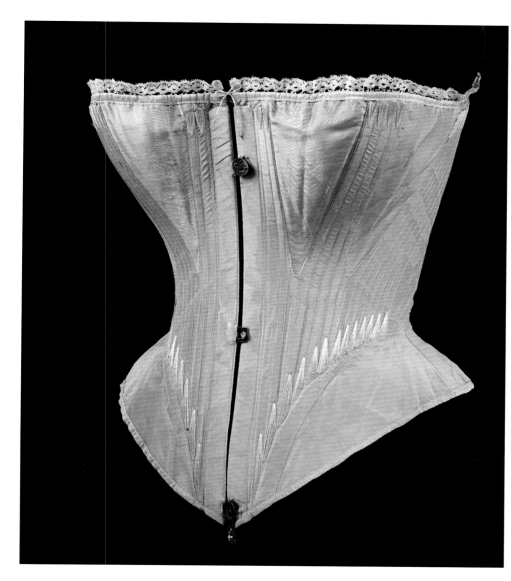

**58. Corset
1864**

England or France
Silk with silk thread
embroidery, machine-made
lace, whalebone, metal and
cotton

Given by the Burrows family
V&A: T.169–1961

**59. Slipper
1850–60**

England
Silk satin embroidered with
chenille and gilt thread and
leather

Given by Mr. G. Dadd
V&A: T.167–1963

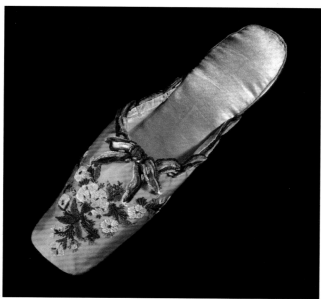

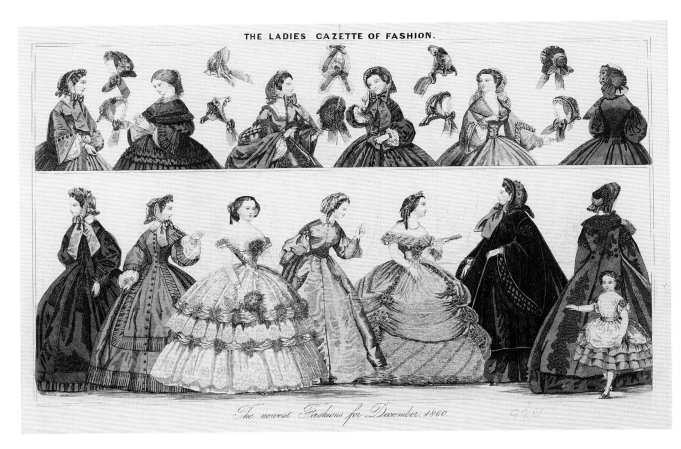

THE LADIES GAZETTE OF FASHION.

The newest Fashions for December 1860.

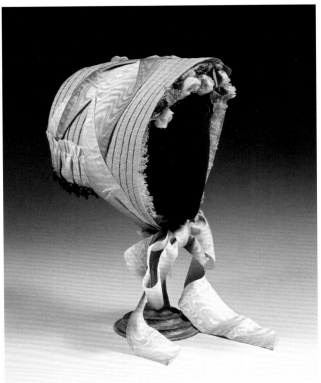

60. Fashion plate from *The Ladies Gazette of Fashion*
December 1860

London
Hand-coloured etching on paper
V&A: E.2229–1934

61. Bonnet
*c.*1860

England
Straw and silk
Given by Miss A. Maishman
V&A: T.103–1972

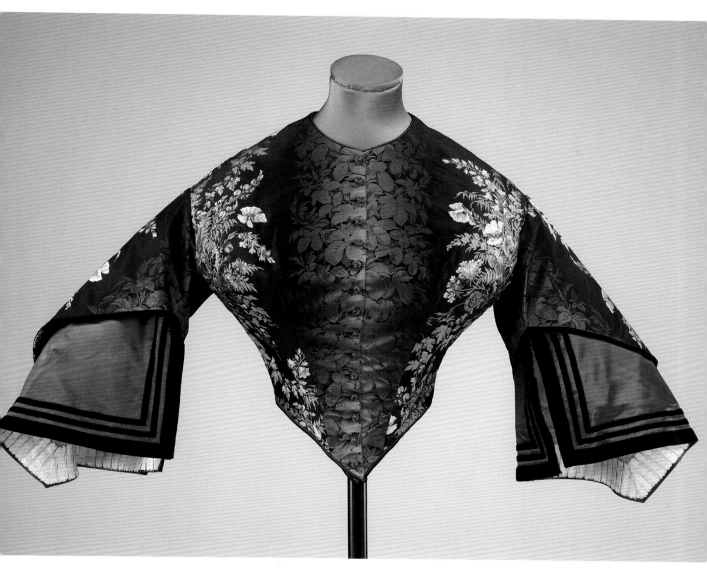

62. Bodice
*c.*1865

This bodice survives with a separate length
of the same fabric, which may have once
been part of a matching skirt. The rich design
exploits the technical brilliance achieved by
French weavers using the Jacquard loom.
The extremely wide 'pagoda' sleeves of the
bodice would have been worn with a pair of fine
white cotton under-sleeves closing at the wrist.

France
Jacquard-woven silk
Given by Mr J. Sassoon
V&A: T.10–1964

Couture
and
Commerce

1870
—1910

The fashion trade was becoming increasingly international, with couture houses producing exquisitely made clothes using superb silks, furs, lace and embroidery. Top couturiers such as Worth and Lucile attracted clients from all over Europe and America, while the British company Redfern established an unrivalled reputation for its tailor-made suits.

Shopping became an activity enjoyed by people at all levels of society. Dressmakers and department stores copied the latest fashions, and many garments could be bought ready-made, including corsets and the different types of bustle required to achieve the fashionable silhouette.

Artists and dress reformers reacted against the artifice of fashion, creating simpler styles using naturally dyed fabrics, and flexible garments of wool jersey for walking and riding. By 1900 these alternative styles had entered mainstream fashion, leading to a more liberating form of dress for women in the twentieth century.

Evening coat (detail of pl.72)
1895–1900

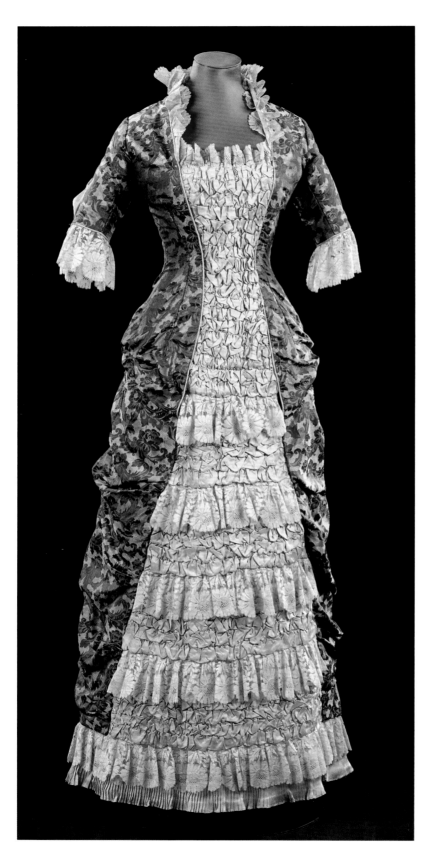

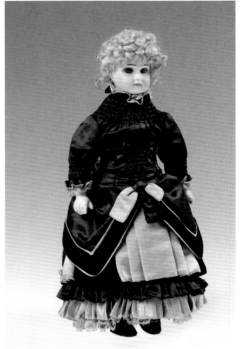

63. Dress
1878–80

Britain
Jacquard-woven silk, silk and machine-
made lace

Given by Miss K. Greaswell
V&A: Circ.606–1962

64. Fashion doll 'Vivienne'
Mrs Latter Axton of Marshall
& Snelgrove; François Gautier (head)
1885–6

Doll: France; ceramic, glass, mohair and wood
Clothing: London; silk and cotton with
leather shoes

Given by Mrs Latter Axton
V&A: T.137–1930

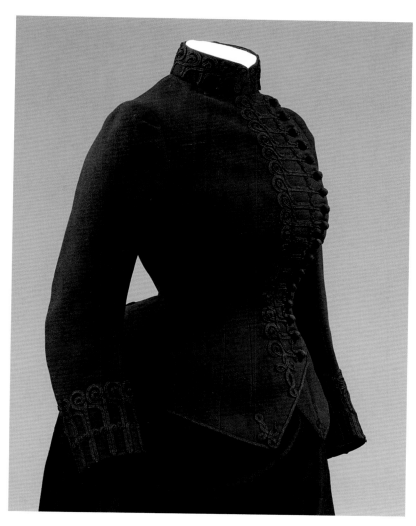

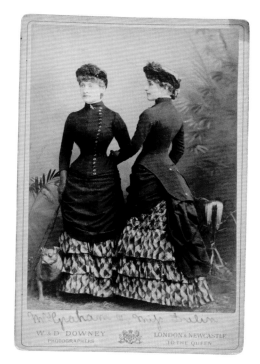

65. Riding habit jacket
Messrs Redfern and Co.
1885–6

London
Wool flannel trimmed with mohair braid
Given by the Honourable Mrs S.F. Tyser
V&A: T.430–1990

66. Photograph of Miss Graham
and Miss Dulin
W. & D. Downey (active 1860s–1910s)
*c.*1885

London
Albumen print
V&A: E.481–1995

67. Handbag
*c.*1889

England
Leather, crocodile and kidskin, with chrome fittings
Given by A. Weingott
V&A: T.61–1956

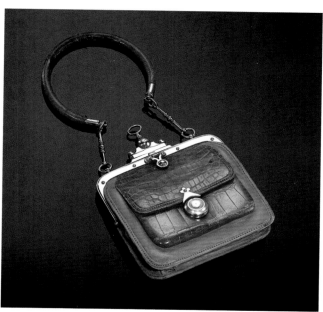

68. Fashion plate from
The Young Ladies' Journal
February 1887

England
Hand-coloured engraving

V&A: E.516–1935

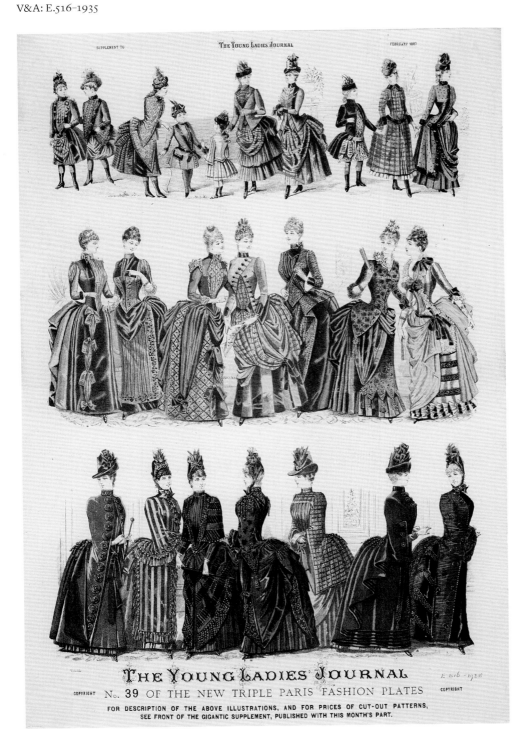

SUPPLEMENT TO THE YOUNG LADIES JOURNAL FEBRUARY 1887

THE YOUNG LADIES JOURNAL
COPYRIGHT No. **39** OF THE NEW TRIPLE PARIS FASHION PLATES COPYRIGHT
FOR DESCRIPTION OF THE ABOVE ILLUSTRATIONS, AND FOR PRICES OF CUT-OUT PATTERNS,
SEE FRONT OF THE GIGANTIC SUPPLEMENT, PUBLISHED WITH THIS MONTH'S PART.

69. Corset (opposite, above)
*c.*1885

England or Germany
Cotton with machine
embroidery, with metal and
whalebone

Given by M. Yanovsky
V&A: T.98&A–1984

**70. Bustle 'The New
Phantom'** (opposite, below)
*c.*1884

England
Steel wires and cotton tapes

Given by Miss Mary
Montefiore
V&A: T.131C–1919

71. Dress
c.1885

England
Printed cotton

Given by Agatha Granville
V&A: T.7&A–1926

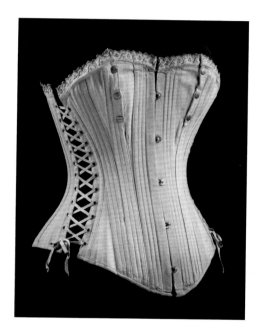

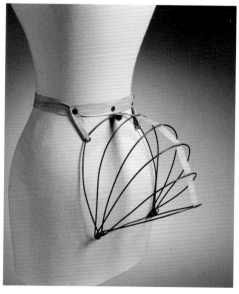

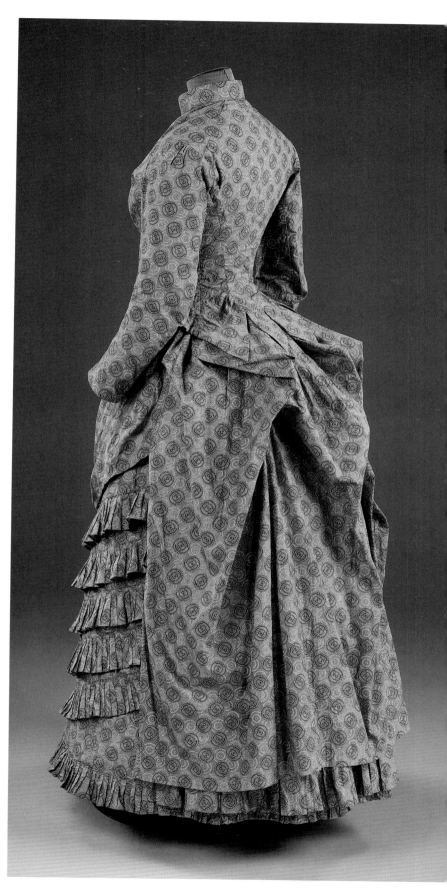

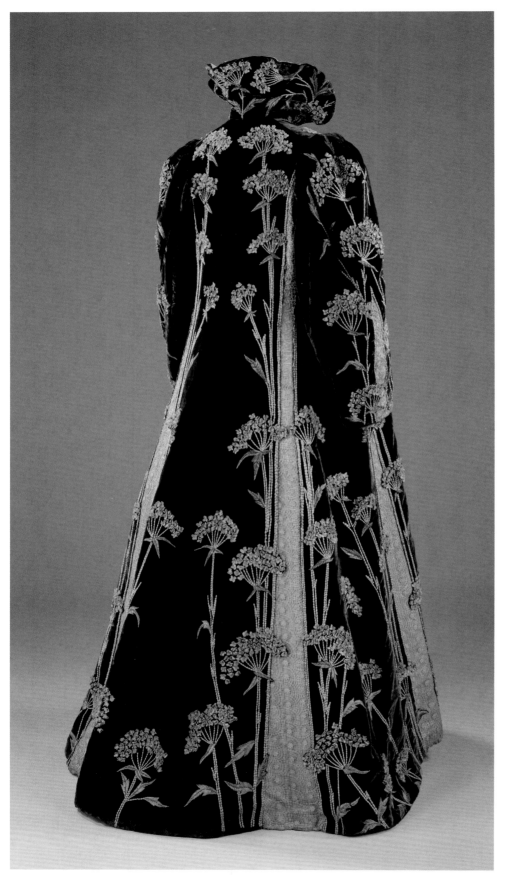

72. Evening coat
Marshall & Snelgrove
1895–1900

The influence of the Arts and Crafts movement can be seen in this bespoke evening coat, with its medieval-style collar and hand-embroidered sprays of cow parsley, evoking an English hedgerow.
A reaction to urbanization and industrialization, the Arts and Crafts movement rejected machine-made production and championed the pastoral simplicity of earlier times.

London
Velvet embroidered with silk thread and wool felt
Given by Mrs A. Poliakoff
V&A: T.49–1962

73. Dress (opposite)
c.1895

Liberty & Co.
London
Silk with smocking and machine-made lace
V&A: T.17–1985

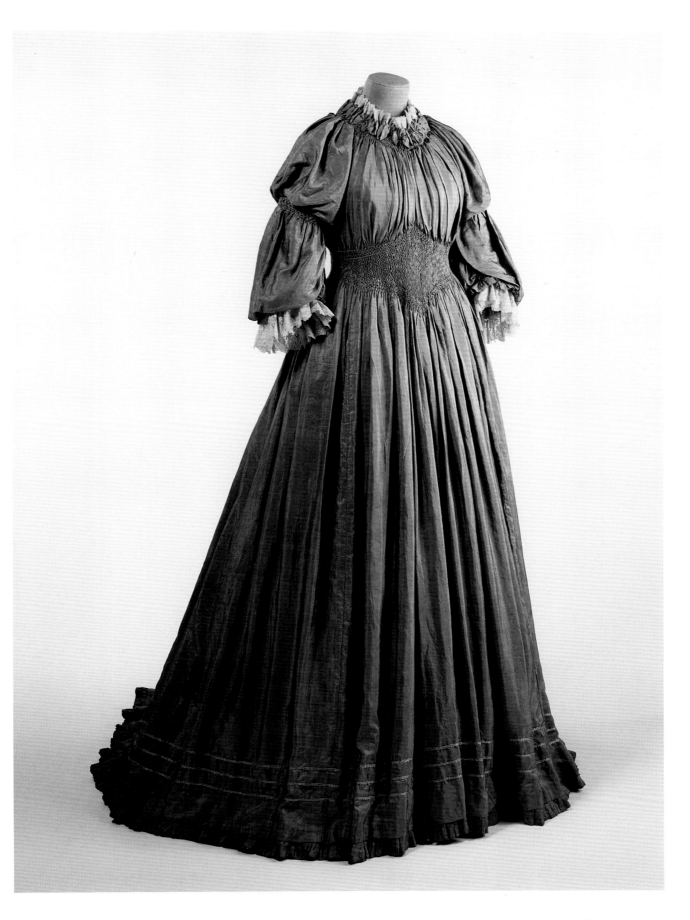

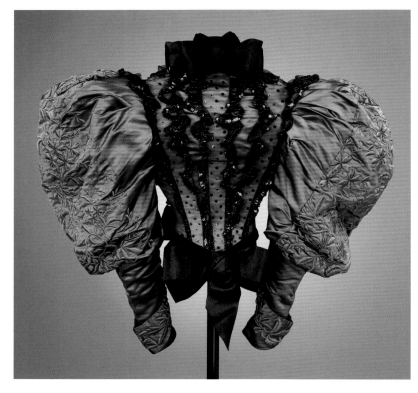

74. Bodice
Mlle L. Guiquin
1895

New York
Silk satin embroidered with raised silk thread,
metal beads, sequins and silk net

Worn by Cara Leland Huttleston Rogers,
later Lady Fairhaven
Given by Major Ailwyn Broughton and
Mrs Broughton
V&A: T.271–1972

75. Dolman
Emile Pingat (active 1860s–1900s)
1885

This dolman (a loose jacket with large sleeves)
epitomizes late nineteenth-century fashion and
taste. It was made by the Paris fashion house
Pingat, which rivalled the House of Worth in
craftsmanship and design. Luxurious materials
such as fur trimming complement the feather
motif voided in the velvet, and reference the
natural world that fascinated Victorians.

Paris
Silk voided velvet trimmed with Arctic fox fur
and silk chenille fringe

Given by Mrs G.T. Morton
V&A: T.64–1976

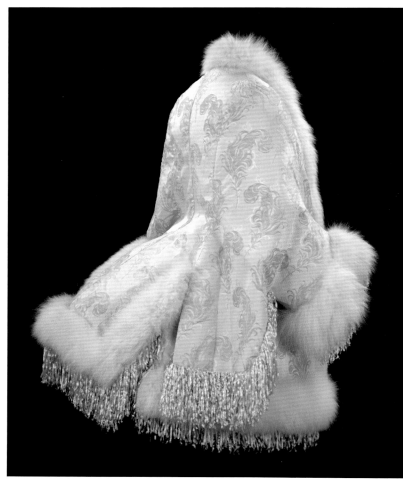

76. Afternoon dress (bodice and skirt)
Sara Mayer & F. Morhange
1889–92

The black ribbons and lace embellishing this dress indicate that it was probably worn when Cara Rogers was mourning her first husband. The daughter of an American industrialist, Cara later married an English engineer who became Lord Fairhaven. Her wardrobe included spectacular outfits purchased from department stores in New York, and Paris couture houses, including Worth.

Paris
Figured silk with chiffon, velvet ribbon and machine lace

Worn by Cara Leland Huttleston Rogers, later Lady Fairhaven
Given by Major Ailwyn Broughton and Mrs Broughton
V&A: T.270&A-1972

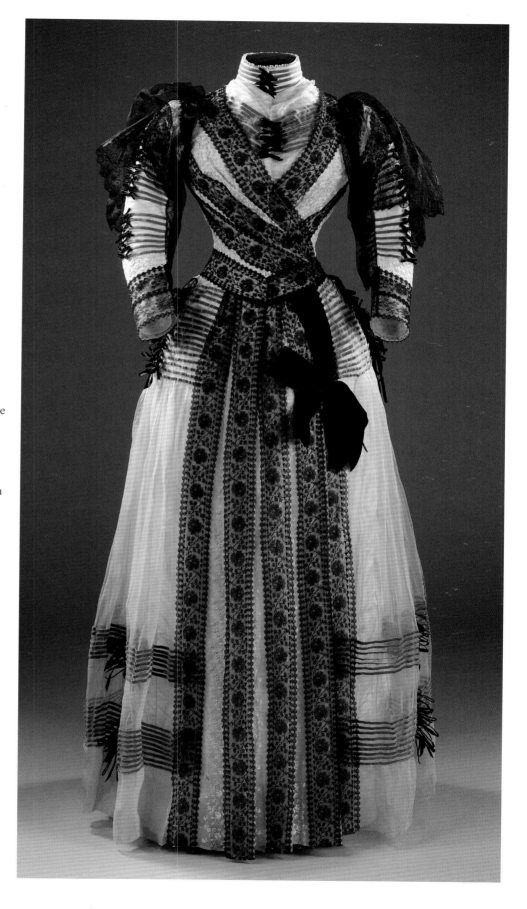

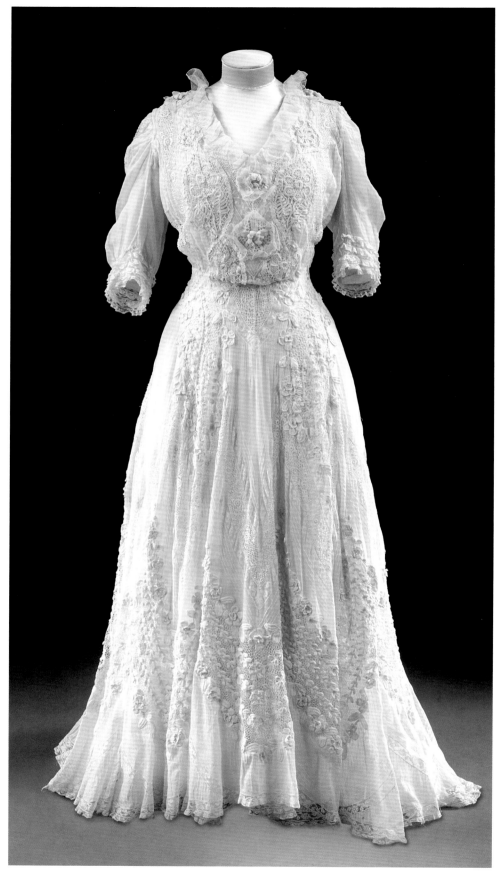

77. Day dress
1904–08

France (possibly)
Cotton lawn with insertions of
crochet and machine lace

Given by The Baron Charles
de Menasce
V&A: T.107–1939

78. Parasol
Mikhail Perkhin (1860–1903) for Fabergé, St Petersburg (handle)
***c*.1900**

Parasols were highly fashionable accessories that also provided protection in the sun. This one, with its handle made by the House of Fabergé, would have been among the most expensive. The collar, with its trelliswork and yellow enamel inset with diamonds, resembles the Imperial eggs for which Fabergé were renowned.

England
Parasol: silk chiffon
Handle: bowenite, two-colour gold, guilloche enamel and diamond

Given by Lady Helen Nutting
V&A: T.39–1958

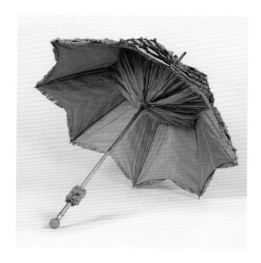

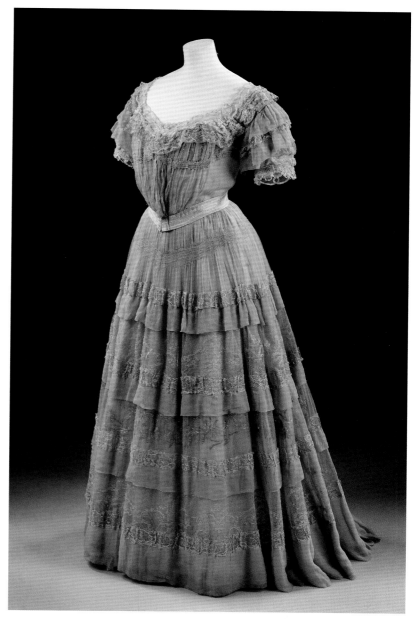

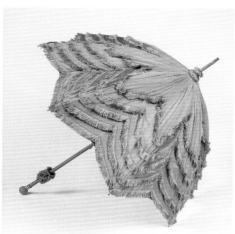

79. Evening dress 'Carresaute'
Lucile (Lady Lucy Duff-Gordon, 1863–1935)
1905

London
Silk chiffon, taffeta, ribbon, silk rose-buds, silver metal strip embroidery, with embroidered net

V&A: T.42:1&2–2007

The Cult of the Kimono

1905–1915

By the turn of the twentieth century, the taste for East Asian art had spread throughout Europe, fuelled by trade and a desire for novelty. Western interpretations of the kimono were sold in London stores such as Liberty & Co., while antique Japanese and Chinese brocades and embroideries were cut up to make new garments.

Parisian couturiers such as Worth adapted the simple, straight lines of the kimono to create spectacular opera cloaks that enveloped the wearer in swathes of expensive silk. Often brightly embroidered, they were designed to be viewed from both front and back for dramatic effect.

Paul Poiret was one of the most innovative couturiers of the time. His dislike of the 'decorated bundles' of Edwardian fashion resulted in garments that were revolutionary in their simplicity. He banished corsets and introduced asymmetrical wraps and high-waisted gowns, incorporating tassels, turbans, fans and boldly patterned textiles, all inspired by Eastern examples.

Evening coat (detail of pl.86)
1913

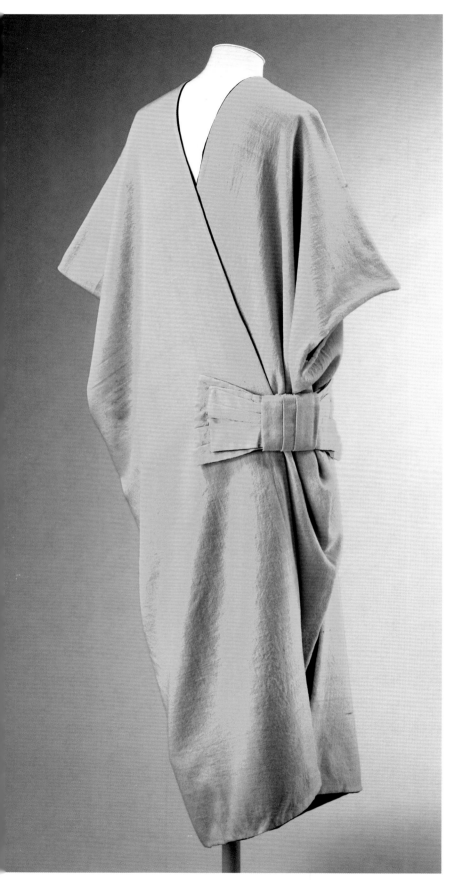

80. Mantle
Paul Poiret (1879–1944)
c.1913

This wool and chiffon mantle draws on a range of artistic and stylistic influences to emphasize the close relationship between art and fashion in the period. Poiret combines the vivid colours of Fauvism with the exoticism of the East in a garment based on a deconstructed kimono.

Paris
Wool and chiffon

Worn by Miss Emilie Grigsby (1876–1964)
V&A: T.165–1967

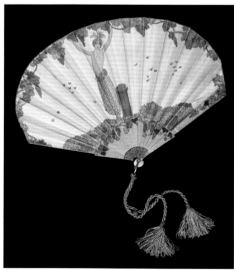

81. Fan
Georges Barbier (designer);
Mme Jean Paquin (maker)
1911

Paris
Hand-coloured paper with silk and bone
V&A: T.333–1978

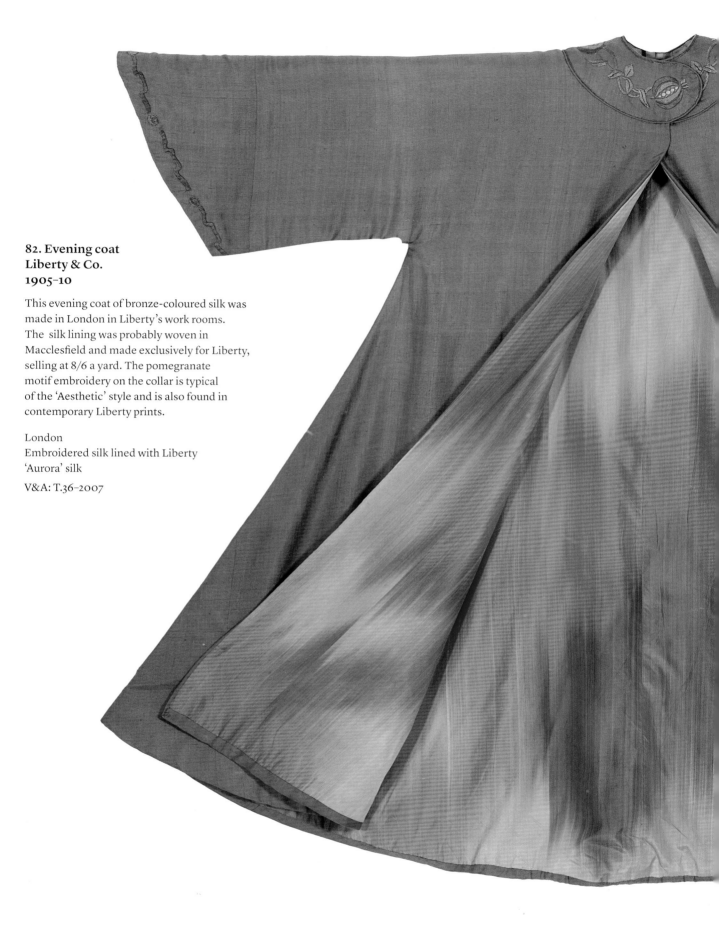

82. Evening coat
Liberty & Co.
1905–10

This evening coat of bronze-coloured silk was
made in London in Liberty's work rooms.
The silk lining was probably woven in
Macclesfield and made exclusively for Liberty,
selling at 8/6 a yard. The pomegranate
motif embroidery on the collar is typical
of the 'Aesthetic' style and is also found in
contemporary Liberty prints.

London
Embroidered silk lined with Liberty
'Aurora' silk

V&A: T.36–2007

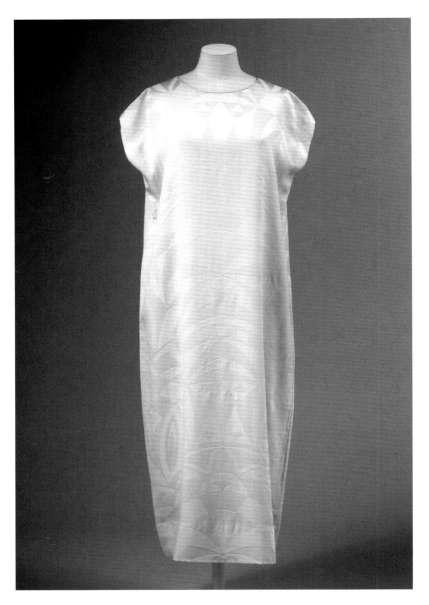

85. Bag
c.1920

France
Glass beads with plastic clasp
V&A: T.189–1997

86. Evening coat (opposite)
Anne Talbot
1913

London
Japanese silk brocade
Worn by Miss Emilie Grigsby (1876–1964)
V&A: T.167–1967

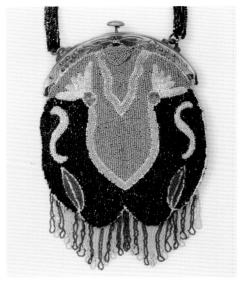

83. Dress '*robe de minute*'
Paul Poiret (1879–1944)
1911

Paris
Figured silk satin
Worn by Denise Poiret
V&A: T.118–1975

84. Shoes
c.1908

Vienna
Leather and jet beads
Retailed by Jack Jacobus Ltd, London
V&A: T292&A–1970

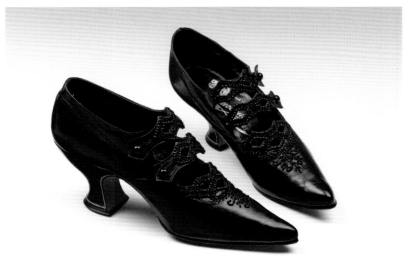

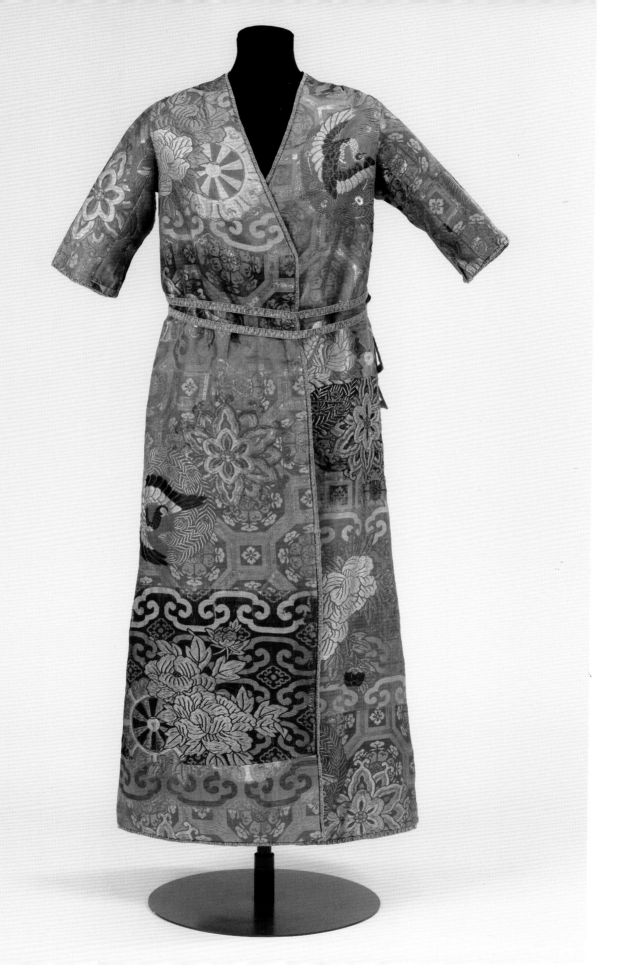

**87. Fashion plate from *Les Choses
de Paul Poiret vues par Georges Lepape***
Georges Lepape (1887–1971)
1911

Paris
Collotype and pochoir
V&A: Circ.270-1976

88. Evening coat (opposite)
**Jean-Philippe Worth (1856–1926)
for House of Worth**
*c.*1909

Paris
Hand-embroidered taffeta and velvet, lined
with chiffon
Given by Lord and Lady Cowdray
V&A: T.207-1970

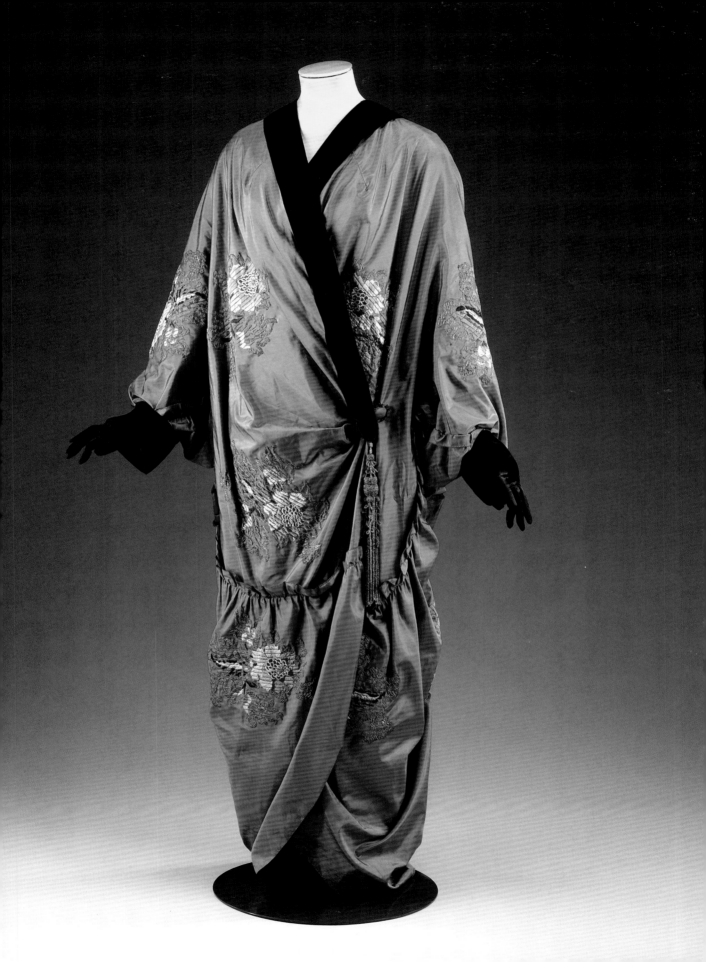

Bright Young Things

1920
—1930

Fashion in the 1920s was dominated by the *garçonne* look. Straight and waistless, the style was modern and liberating. Delicate silk and chiffon became popular for underwear, while girdles and bandeaux bras were worn to smooth the figure into the desired boyish shape. Hair was cropped short and close-fitting cloche hats became popular. Couture houses such as Callot Soeurs and Voisin created evening dresses in light-weight fabrics, worn with long strings of beads. And as skirts became shorter, shoes were a focal point: silver and gold glacé kid was popular for evening wear.

The fashion for rich and sensuous detail continued with fringed shawls, dresses embroidered in the Chinese style and evening coats trimmed with fur. The excavation of Tutankhamen's tomb in 1922 prompted a wave of Egyptian-inspired fashions, with ostrich feather fans and accessories adorned with hieroglyphs.

Evening dress (detail of pl.94)
1922–5

**89. Fashion plate
'La Belle Dame
Sans Merci' from
La Gazette du Bon Ton
Georges Barbier
(1882–1932)
June 1921**

Paris
Print after a drawing by
Georges Barbier; half-tint
block with pochoir

Circ.140–1975

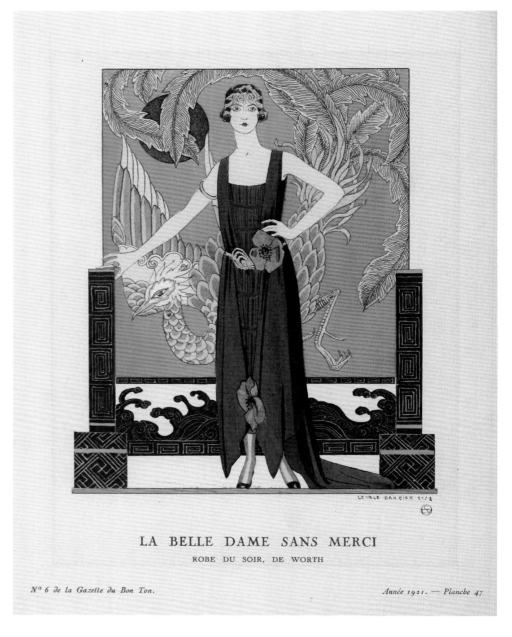

LA BELLE DAME SANS MERCI

ROBE DU SOIR, DE WORTH

Nº 6 de la Gazette du Bon Ton. Année 1921. — Planche 47

90. Evening dress (opposite)
Voisin
*c.*1925

This fine silk velvet flapper dress has orange and peach velvet streamers fringed
with gold bugle beads designed to enhance lively dance movements.

Paris
Silk velvet with beaded fringes

Worn by Miss Emilie Grigsby (1876–1964)
V&A: T.139&A–1967

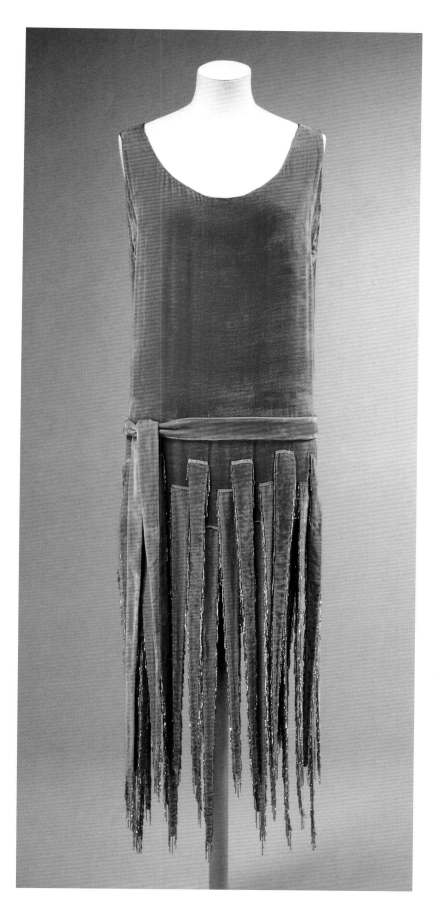

91. Shawl
Langley Prints
1920

England
Printed silk

Given by Langley Prints
V&A: T.83–1964

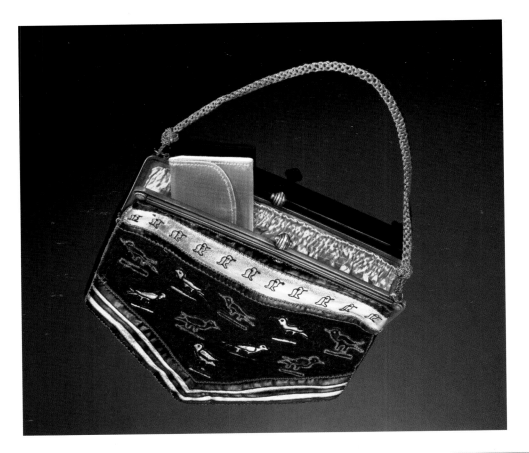

92. Evening bag
c.1924

This green felt handbag with applied bands of
black and gold leather has an appliqué design
of birds in the popular Egyptian style of the
time. The brass clasp opens to reveal a ruched
yellow satin lining and tiny coin purse.
The cord handle is made from plaited wire.

France
Leather, brass, satin, wire

Worn by Cara Leland Huttleston Rogers,
later Lady Fairhaven
Given by Major Ailwyn Broughton and
Mrs Broughton
V&A: T.236&A-1972

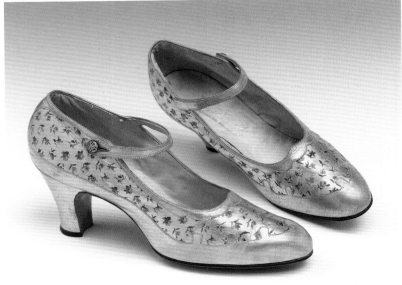

93. Evening shoes
c.1925

Belgium
Leather

Retailed by Lilley & Skinner
Given by Miss K.M. Dunbar
V&A: T.125&A-1962

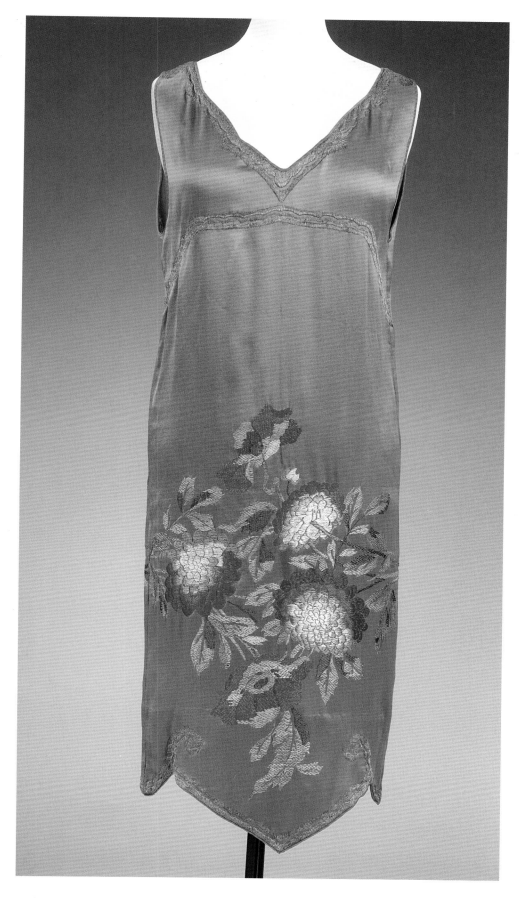

**94. Evening dress
Callot Soeurs
1922–5**

Paris
Embroidered silk satin

Given by Lady Lebus
V&A: T.73–1958

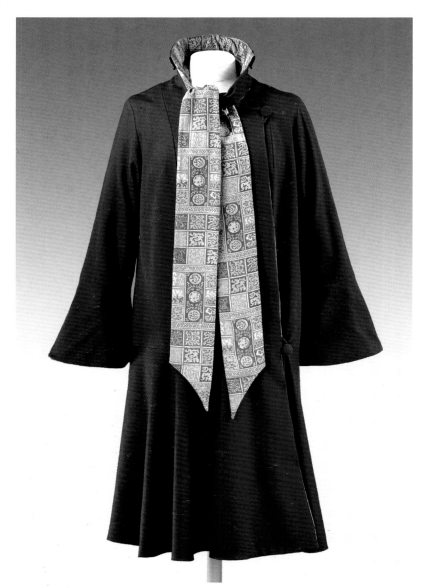

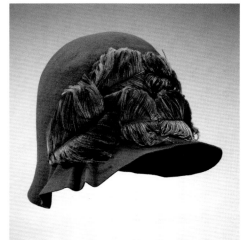

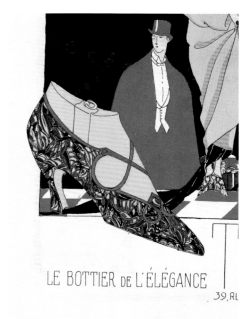

LE BOTTIER DE L'ÉLÉGANCE

39.RU

95. Coat
Liberty & Co.
1928

London
Wool and printed silk satin

Worn by Marian Hazel Lasenby
V&A: T.71–1982

96. Hat
Liberty & Co.
1928

London
Wool felt with ostrich feathers

Worn by Marian Hazel Lasenby
V&A: T.71&B–1982

**97. Fashion plate 'Le Bottier
de L'Elegance' from *Art, Goût,
Beauté*** (detail)
March 1925

Paris
Print
NAL: 95.SS.15–17

98. *Vogue* cover (opposite)
January 1925
Georges Lepape
(1887–1971)

London
Halftone colour offset
lithograph
NAL:PP.1.A

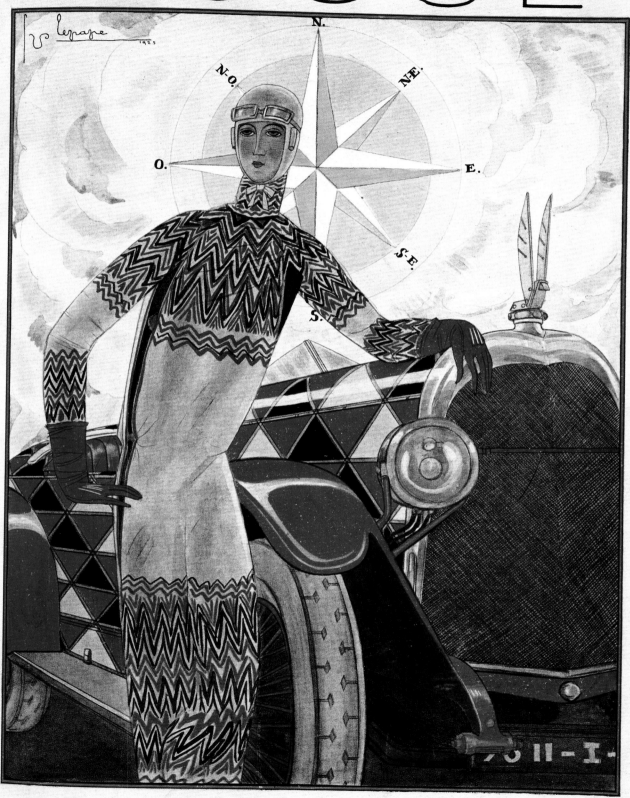

The Modern Woman

1925 –1940

The 1920s and 1930s saw a new freedom for women in dressing for sport and leisure. Many designers introduced 'resort' collections for the smart set, using innovative fabrics such as jersey. 'Coco' Chanel championed the trouser suit and even created a de luxe evening version in shimmering sequins, while Elsa Schiaparelli challenged the grand couture houses of Paris with her dramatic and witty collections, making a virtue out of new zip fastenings and introducing a range of perfumes. Other designers also created perfumes to help market their brand.

The fashionable gamine look of the 1920s matured into the sophisticated glamour of Art Deco, with clinging full-length dresses cut on the bias for a closer fit, gleaming satins and silks and polished metal clutch bags.

Evening dress (detail of pl.110)
1938

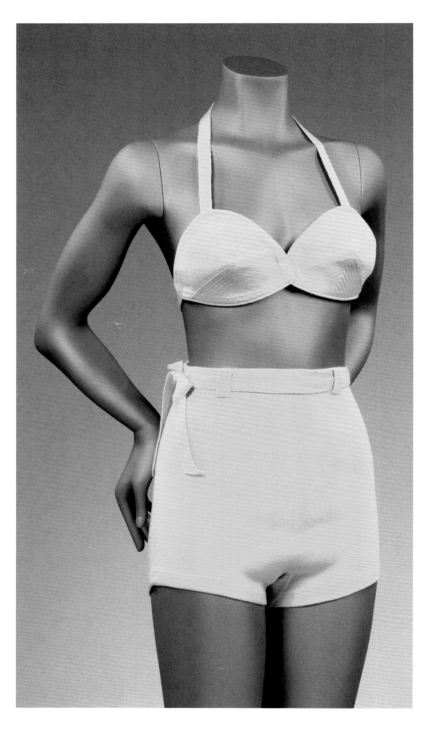

99. Bathing costume
1937–9

By the mid-1930s, two-piece bathing suits were worn, yet even in 1946, when the term 'bikini' was coined, the style was still viewed as somewhat risqué. Before the advent of synthetic fibres, wool was the best option for a colour-fast fabric which would allow for stretch and shape retention.

Wool jersey

Worn by Lady Vera Swettenham
Retailed by Finnigans, New Bond Street, London
V&A: T.294&A-1971

100. Design for a beach outfit
Victor Stiebel (1907–76)
*c.*1934

London
Pencil and watercolour on paper
V&A: E.1074-1983

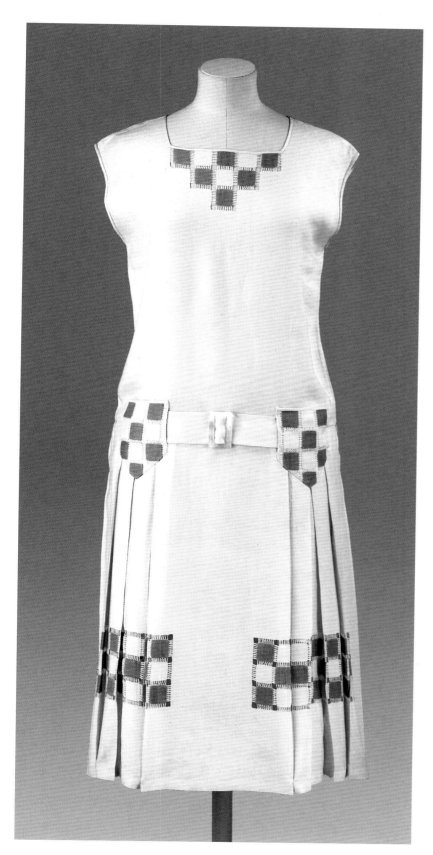

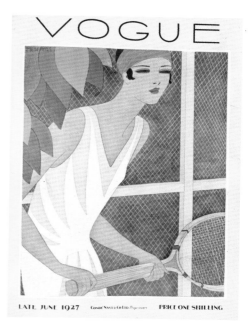

101. Tennis dress
Hepburne Scott
1926

Scotland
Linen with drawn thread work
Given by Miss Hepburne Scott
V&A: T.260–1976

102. *Vogue* cover (above)
Harriet Meserole
June 1927

London
Halftone colour offset lithograph
NAL: PP.1.A

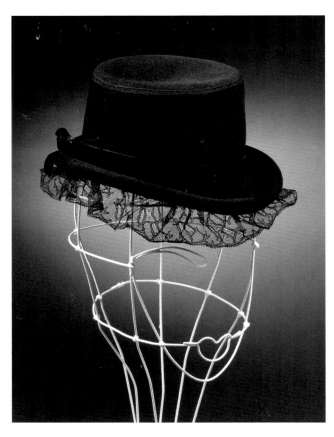

103. Hat
Elsa Schiaparelli (1890–1973)
1938

In the late 1930s, fashionable hats were small and often whimsical. Hats offered much scope for Schiaparelli's Surrealist tendencies and often suggest found objects or play with scale. Here, Schiaparelli takes the traditional man's top hat and shrinks it, adding a veil for feminine allure.

Paris
Felt and lace
Given by Miss Ruth Ford
V&A: T.411–1974

shown on image with

Hat stand
1971

This hat stand is from Cecil Beaton's exhibition *Fashion: An Anthology* (V&A 1971) which incorporated Surrealist elements in the exhibition design.

London
Wire
V&A Furniture, Textiles and Fashion department archive

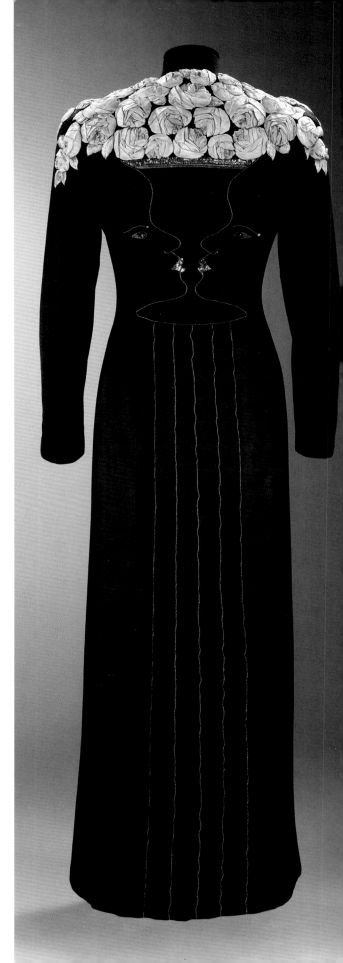

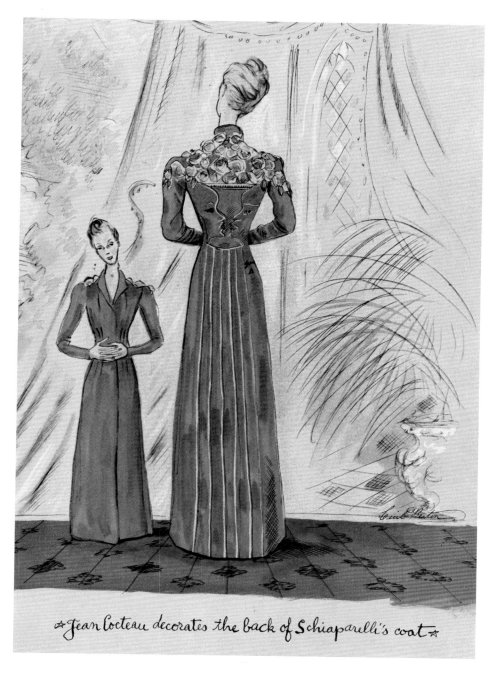

Jean Cocteau decorates the back of Schiaparelli's coat

105. Sketch of evening coat by Elsa Schiaparelli and Jean Cocteau
Cecil Beaton (1904–80)

Published in *Vogue* (American edition)
15 July 1937, p.58
© ADAGP, Paris and DACS, London 2013

104. Evening coat (opposite)
Elsa Schiaparelli (1890–1973)
Autumn 1937

This coat depicts a profusion of roses in an urn, which can also be viewed as two faces in profile; the double image held a particular fascination for Surrealist artists. The embroidery is by the Paris house of Lesage, after a drawing by Jean Cocteau.

Silk jersey with gold thread and silk embroidery and applied decoration in silk

Worn by Doris Castlerosse
Given by the American Friends of the V&A
V&A: T.59-2005

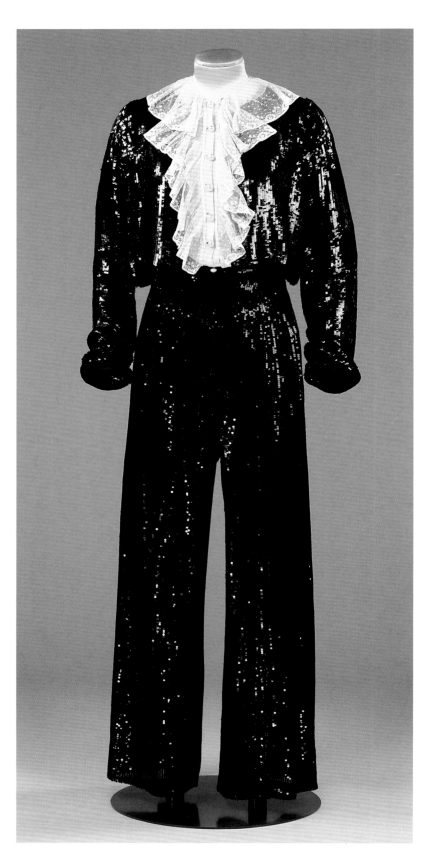

106. Evening trouser suit and blouse
Gabrielle 'Coco' Chanel (1883–1971)
1937–8

A trouser suit was a very daring choice for a woman in the 1930s. Chanel took the pyjama suit, first fashionable in the 1920s, and combined it with elements of a man's tuxedo and a woman's sequinned evening dress. She found the perfect wearer in the fearless fashion editor Diana Vreeland.

Paris
Trousers: net with sequins
Blouse: silk chiffon with lace and mother-of pearl
Worn and given by Mrs Diana Vreeland
V&A: T.88 to B–1974

107. Evening dress (opposite)
Madeleine Vionnet (1876–1975)
1935

Paris
Machine-made lace, silk and organza
Worn by Lady Minoru Foley
Purchased with support from the Director's Circle
V&A: T.378:1–2009

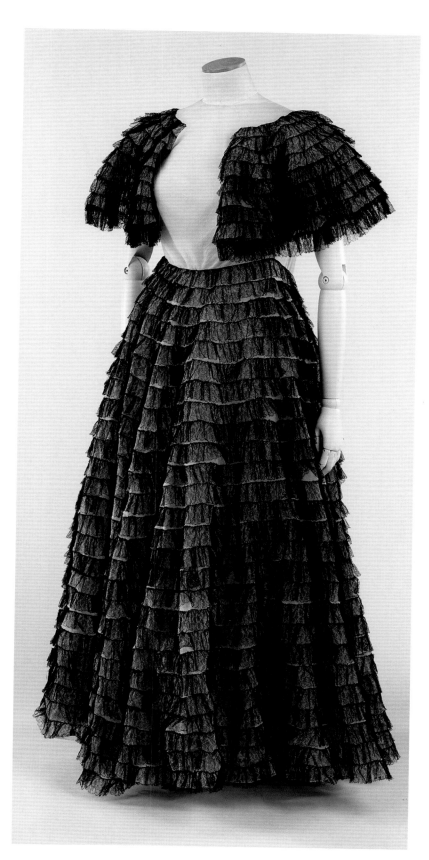

108. Handbag
1925–30

Paris
Textured aluminium and Bakelite
V&A: T.238–1982

109. Roll of dress labels
Charles James (1906–78)
*c.*1936

London
Woven silk

Bequeathed by Miss Philippa Barnes
V&A: T.292–1978

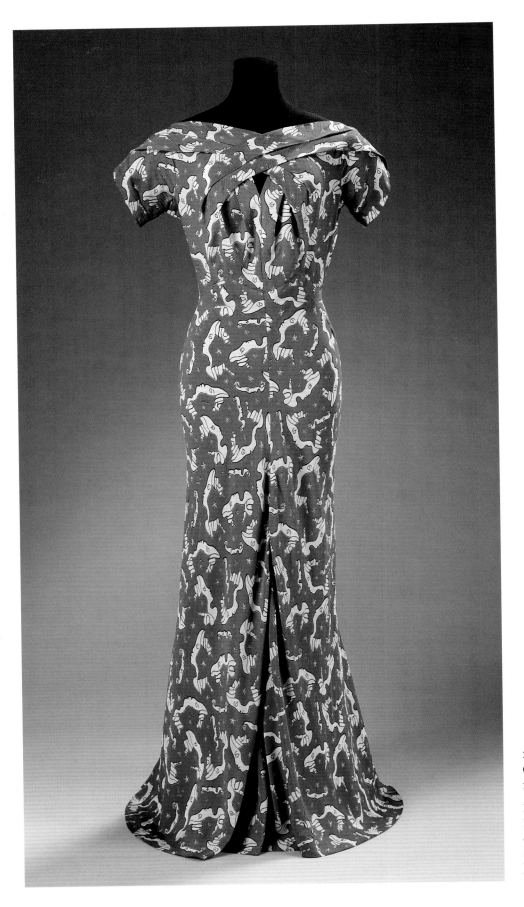

**110. Evening dress
Charles James (1906–78)
1938**

Paris or London
Printed silk

Textile designed by
Jean Cocteau (1889–1963)

V&A: T.274-1974

111. Shoes
Jack Jacobus Ltd
*c.*1930

Britain
Gilded leather

Worn and given by H.M. Queen Elizabeth,
the Queen Mother
V&A: T.473:1&2–1997

112. Evening dress
Jeanne Lanvin (1867–1946)
*c.*1936

The work of Parisian designer Jeanne Lanvin
was marked by an understated elegance.
The softly gathered chiffon ground suggests
classical drapery, emphasized with precisely
applied vertical gold leather strips which
appear to 'rain' down the dress. Marrying
such disparate materials required great
technical skill.

Paris
Silk chiffon with gilded kid leather

Given by Lady Glenconner
V&A: T.61–1967

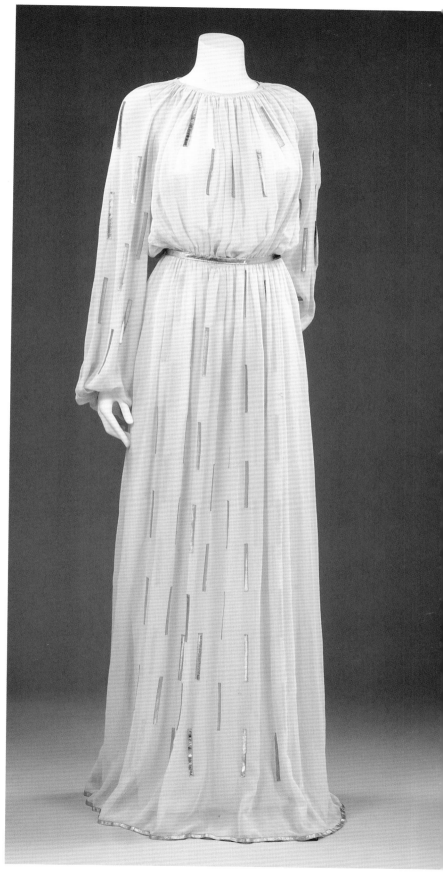

Tailored to Fit

1940
—1960

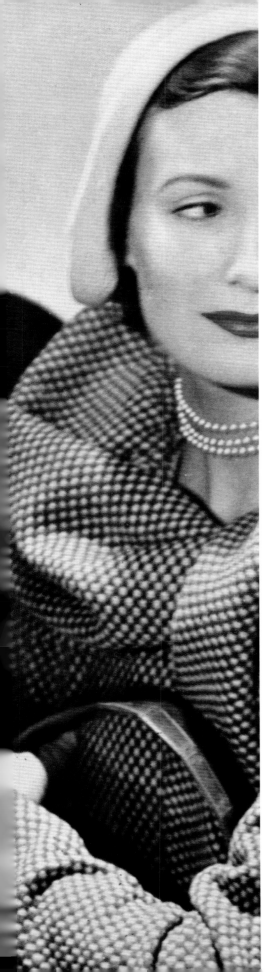

Before the Second World War, bespoke fashion in London was mainly the work of tailors and court dressmakers. The Incorporated Society of London Fashion Designers (INCSOC) was formed in 1942, with most of its members based in Mayfair and Savile Row. They became known for their practical, beautifully made tailoring using the finest tweeds and woollen fabrics from Scotland.

During the war the Board of Trade commissioned INCSOC to design a Utility collection, and a selection was mass-produced following the strict clothing regulations: skirts were limited to knee length, no pleats or folds were allowed, and jackets could only have three buttons.

In the late 1940s the square-shouldered, masculine fashions of the war changed in response to Christian Dior's 'New Look' with its voluptuous silhouette. Skirts became fuller and longer, shoulders were softened and hips were padded, emphasizing the fashionably small waist.

Vogue **cover** (detail of pl.117)
March 1949

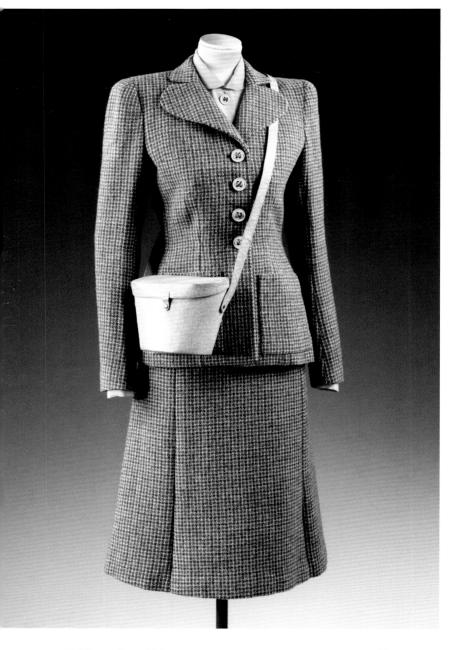

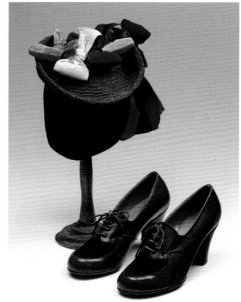

114. Hat

England
Straw trimmed with velvet ribbons

Worn by Doris Langley Moore, the founder of
the Museum of Costume, Bath
Retailed by Marshall & Snelgrove, Harrogate
V&A: T.108–1980

shown on image with

Shoes
Burlington FHW Utility
1942

England
Leather
V&A: T.300&A–1970

113. Utility suit and blouse
Elspeth Champcommunal for Worth
Autumn 1942

London
Suit: Scottish woollen tweed
Blouse: rayon crepe

Given by the Board of Trade, through Sir
Thomas Barlow, Director-General of Civilian
Clothing
V&A: T.42&A, 63&A–1942

shown on image with

Gas mask bag
H. Wald & Co.
1940–42

Great Britain
Reptile skin
Given by Deborah Wald
V&A: T.542:1–1996

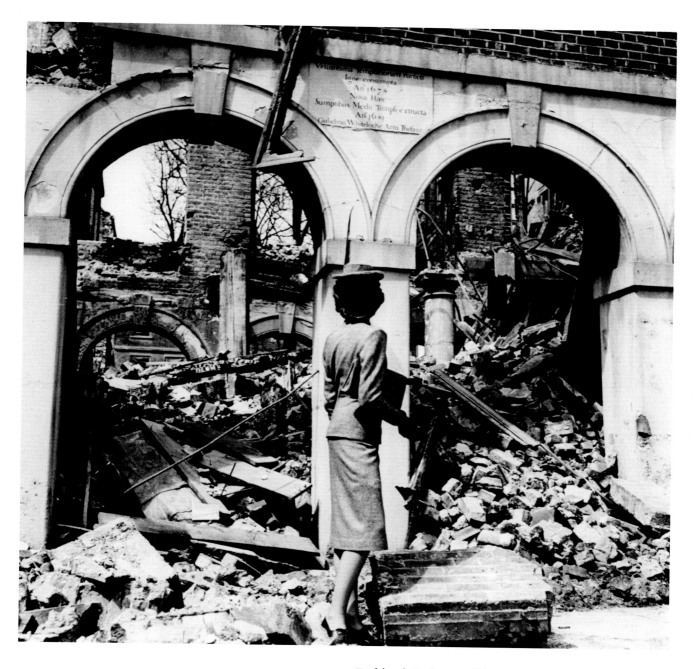

115. *Fashion is Indestructible*
Photograph by Cecil Beaton (1904–80)
Vogue **(British edition)**
September 1941

In this photograph a model wearing a suit by Digby Morton stands before the ruins of the Temple Church, London, which was bombed on 10 May 1941. British *Vogue*'s readership soared during the Second World War; as the title suggests, maintaining an interest in fashion was considered an important morale booster.

London
Gelatin-silver print

© Cecil Beaton
V&A: Ph.960–1978

116. Dress and jacket
Digby Morton (1906–1983)
1947–8

London
Wool, velvet, leather and grosgrain

Given by Mrs Benita Armstrong
V&A: T.37 to B-1966

117. *Vogue* cover
March 1949

England
Halftone colour effect lithograph

V&A Furniture, Textiles and Fashion
department archive

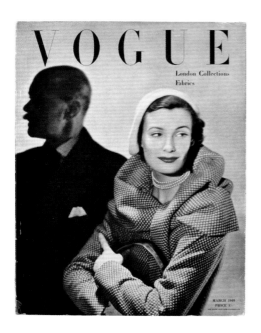

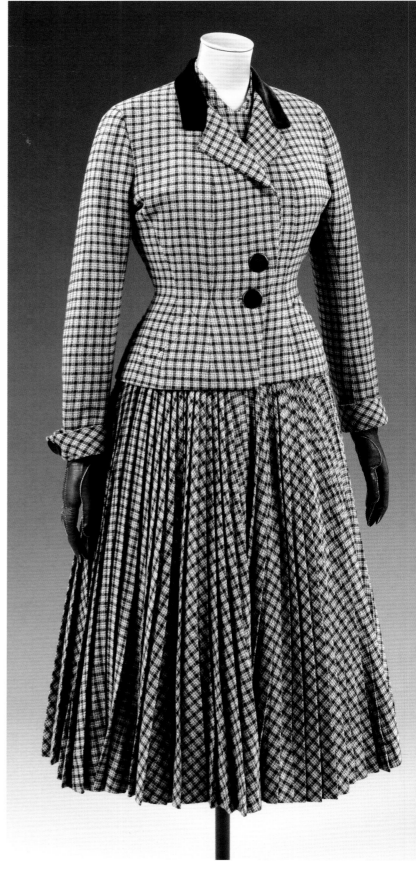

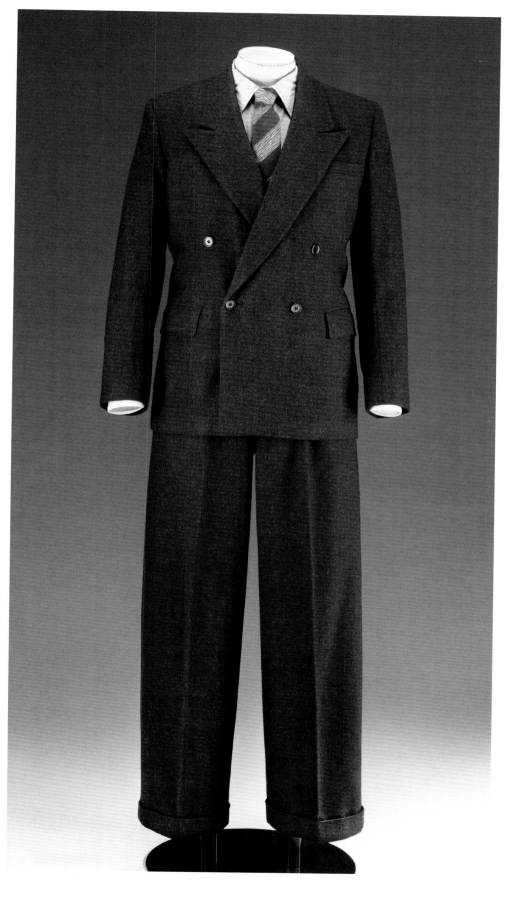

118. Utility suit
*c.*1941

Britain
Wool lined with rayon and
cotton
V&A: T.242&A-1981

shown on image with

Utility shirt
1942–50

Britain
Cotton

Given by Mr David Oxford
V&A: T.582–1995

Tie
1940–50

Britain
Rayon

Given by Mr G. Neuhofer
V&A: T.329–1982

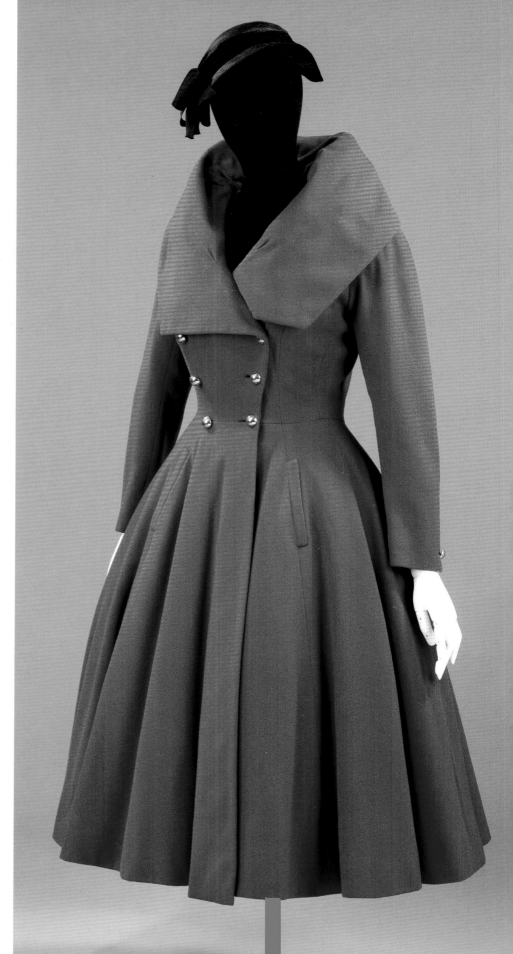

119. Coat
Hardy Amies (1909–2003)
1947–8

London
Wool

Given by Mrs Benita
Armstrong
V&A: T.35–1966

shown on image with

Hat
Alice Camus
*c.*1945

London
Straw and silk ribbon
Given by Mrs. P. Pepper
V&A: T.35–1966

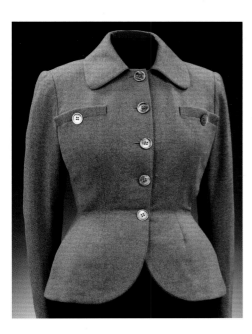

120. 'New Look' Jacket
Christian Dior (1905–57)
1947–48

Wool flannel

Given by Mrs D.M. Haynes and Mrs M. Clark
V&A: T.109–1982

121. Suit
Michael (Michael Donéllan, 1917–85)
1954

Michael began his career at the London
tailoring firm of Lachasse and opened his own
house in Carlos Place in 1953. This chic black
suit was ordered in spring 1954. The close-
fitting jacket buttons from Peter Pan collar to
waist, ending with a pair of buttons that, like
the curved pockets, emphasize the hips.

London
Worsted wool

Given by Dr Vivienne Cohen
V&A: T.52:1,2–1997

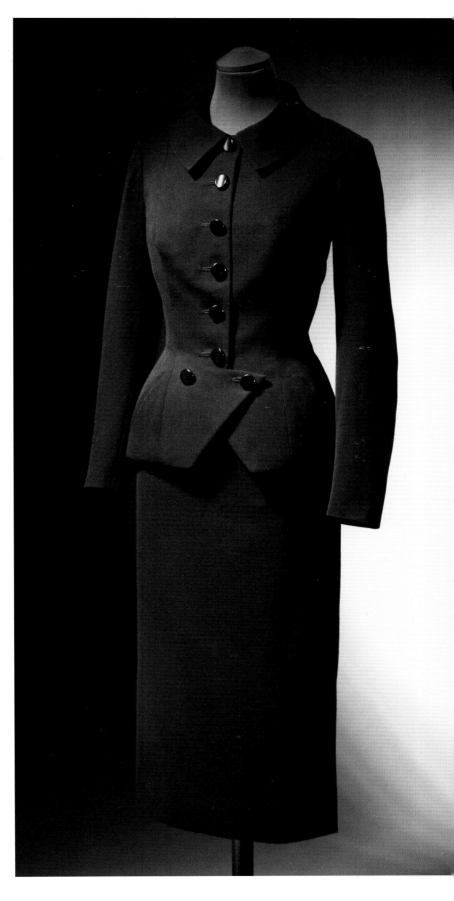

The Pursuit of Perfection

1947
−1960

Paris was renowned worldwide as the centre of luxurious high fashion; thousands of people were employed in the trade, which was a vital part of France's economy. After the Second World War, designers such as Christian Dior, Balenciaga and Givenchy became household names, their collections dictating changes in style.

The couture houses were regulated by the Chambre Syndicale de la Couture Parisienne. Their exclusive reputations were dependent on the high quality of their work, which was shown through seasonal collections.

Haute couture was a handcraft industry. Each garment was ordered and made to measure for the individual client and was made in-house by specialist dressmakers and tailors. Embroidery, beading, feather and flower work was outsourced to ateliers such as Rébé, Lesage and Lemarié.

Cocktail dress (detail of pl.124)
1951

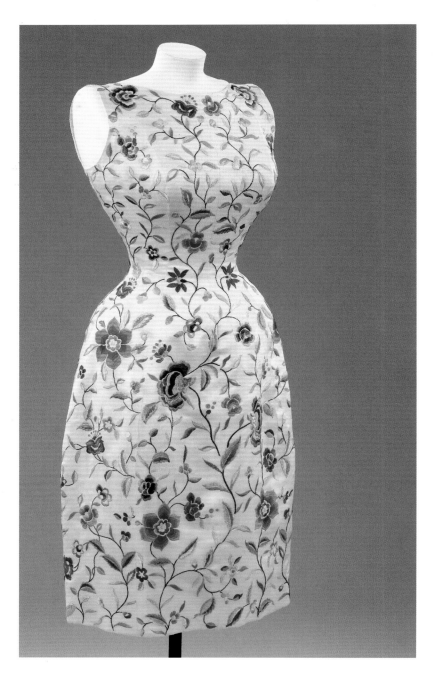

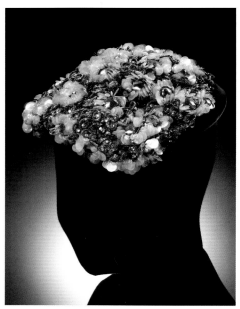

123. Hat
Rébé
*c.*1950

Paris
Velvet with sequins and beads

Given by Miss Catherine Hunt
V&A: T.111–1970

122. Cocktail dress
Cristóbal Balenciaga (1895–1972)
Summer 1960

The floral silk embroidery on this dress is by Lesage, and was applied once the garment was made. The vibrant design evokes the lavishly embroidered and fringed Manila shawls of Balenciaga's native Spain. Like all haute couture garments, the dress was made to measure, in this case accentuating the hour-glass figure of the wearer.

Paris
Hand-embroidered wild silk

Worn and given by Viscountess Lambton
V&A: T.27–1974

124. Cocktail dress (opposite)
Jean Dessès (1904–70)
1951

Paris
Silk, silk organza and velvet ribbon, pleated

Worn and given by H.R.H. Princess Margaret
V&A: T.237–1986

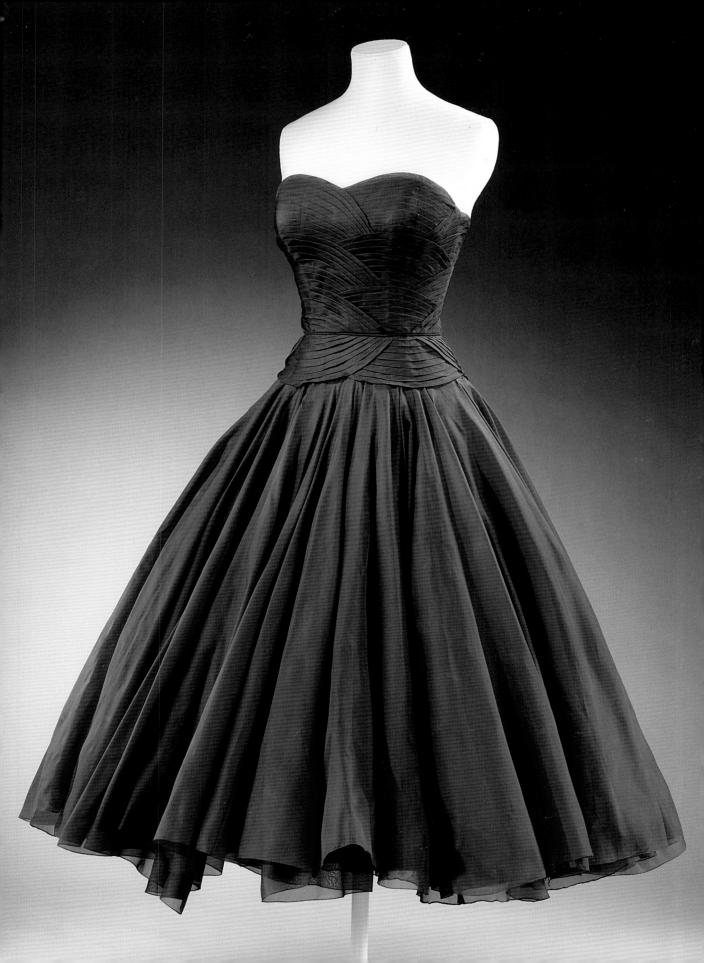

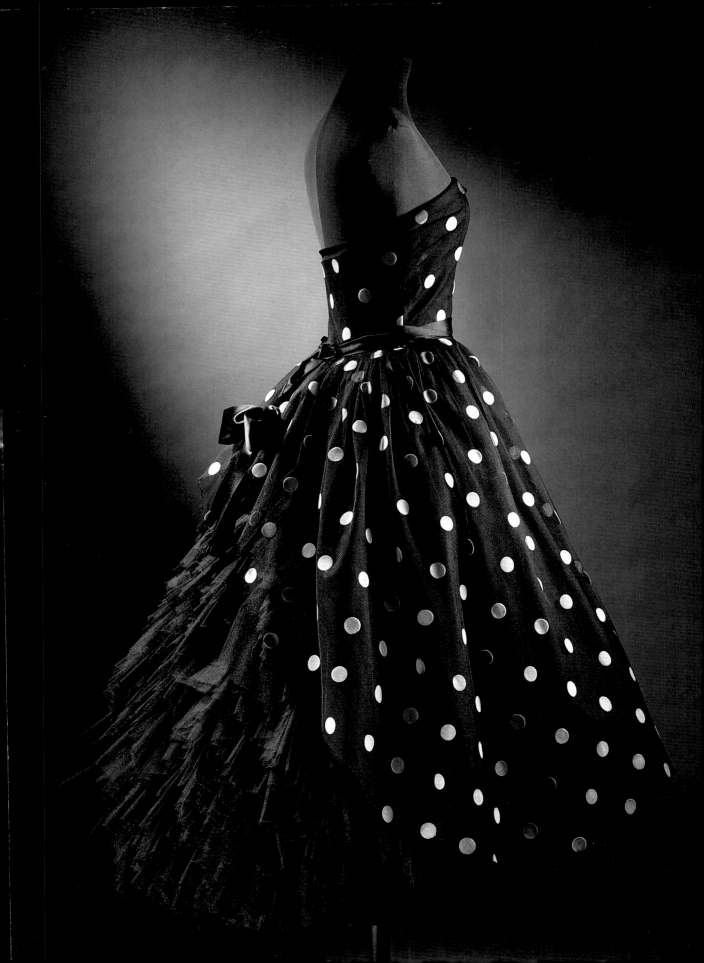

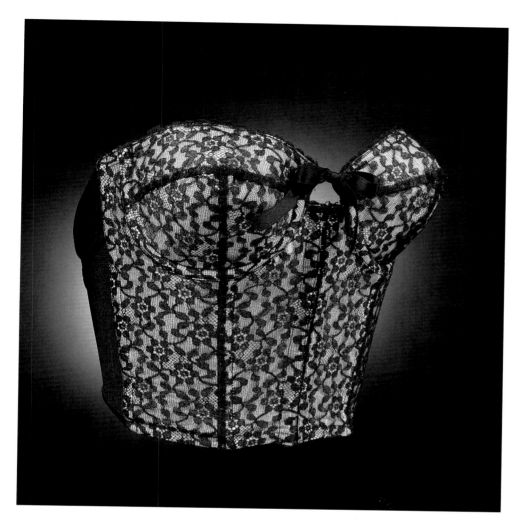

126. Corset
Kestos
c.1953

London
Nylon, lace, elastic, wire
Given by Ruth Sheradski
V&A: T.294–1977

127. Shoe (below)
Roger Vivier (1913–98)
for Christian Dior
1954

France
Tulle and satin
Given by the designer
V&A: T.148–1974

125. Cocktail dress, 'Tuileries' (opposite)
Lanvin Castillo
Spring/Summer 1957

The Spanish designer Antonio Cánovas del Castillo del Rey
(1908–84) joined the venerable house of Lanvin in 1950.
This cocktail dress in the flamenco style was featured in French
Vogue, April 1957, complete with mantilla. The huge flounce at
the rear made sitting down problematic.

Paris
Dress: crepe-de-Chine net with felt polka dots
Petticoat: silk taffeta, net and gauze

Given by Stella, Lady Ednam
V&A: T.52&A–1974

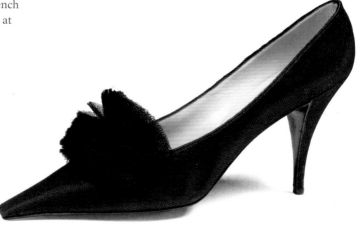

128. 'Zemire' modelled by Dior house model Renée
Photograph by Regina Relang
(1906–89)
1954

Paris

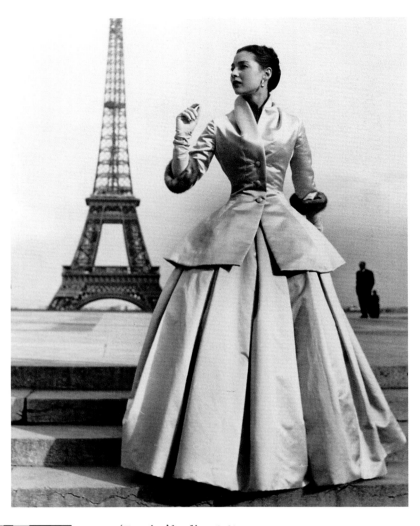

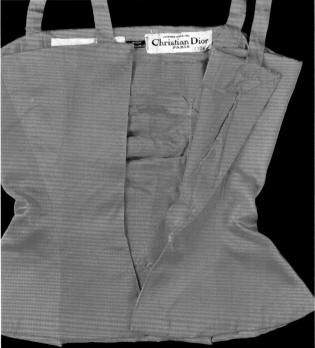

129. 'Zemire' bodice (left)
Christian Dior (1905–75)
Autumn/Winter 1954–5

from

130. 'Zemire' evening ensemble (opposite)
(jacket, skirt, bodice and under-petticoat)
Christian Dior (1905–57)
Autumn/Winter 1954–5

Christian Dior often made reference to historical dress in his collections. 'Zemire' was named after the opera *Zémire et Azor* (Beauty and the Beast) by André Grétry, first performed at Fontainebleau in 1771. The play bill features a fur-trimmed jacket and full skirt, which may have inspired Dior's striking design, originally created in grey satin (see above).

Paris
Synthetic silk, silk and net

Worn by Lady Agota Sekers
V&A: T.24:1 to 5-2007

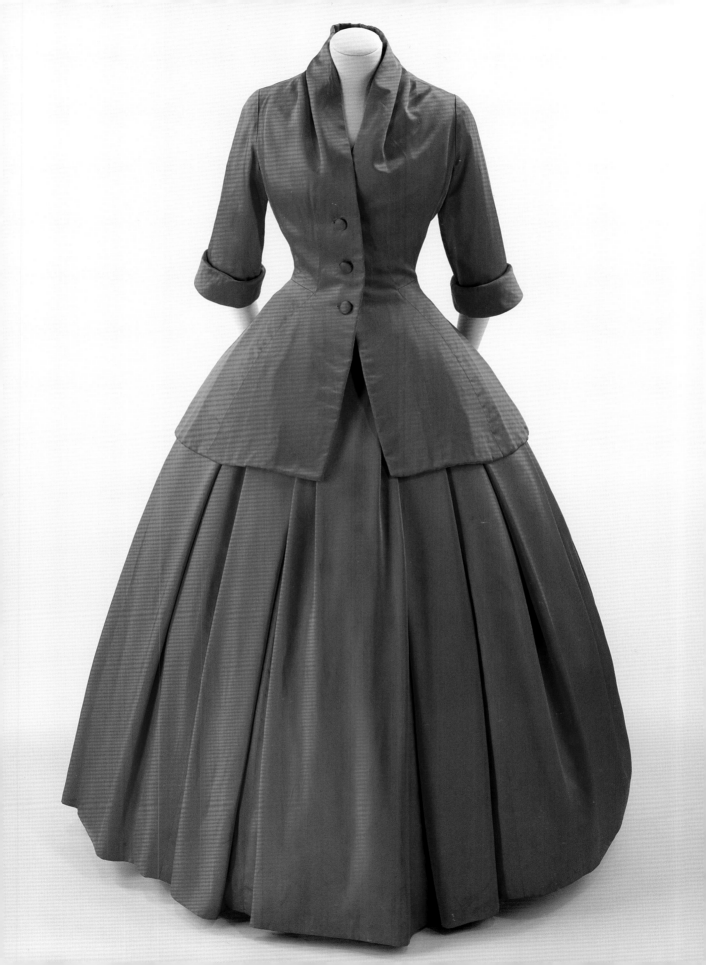

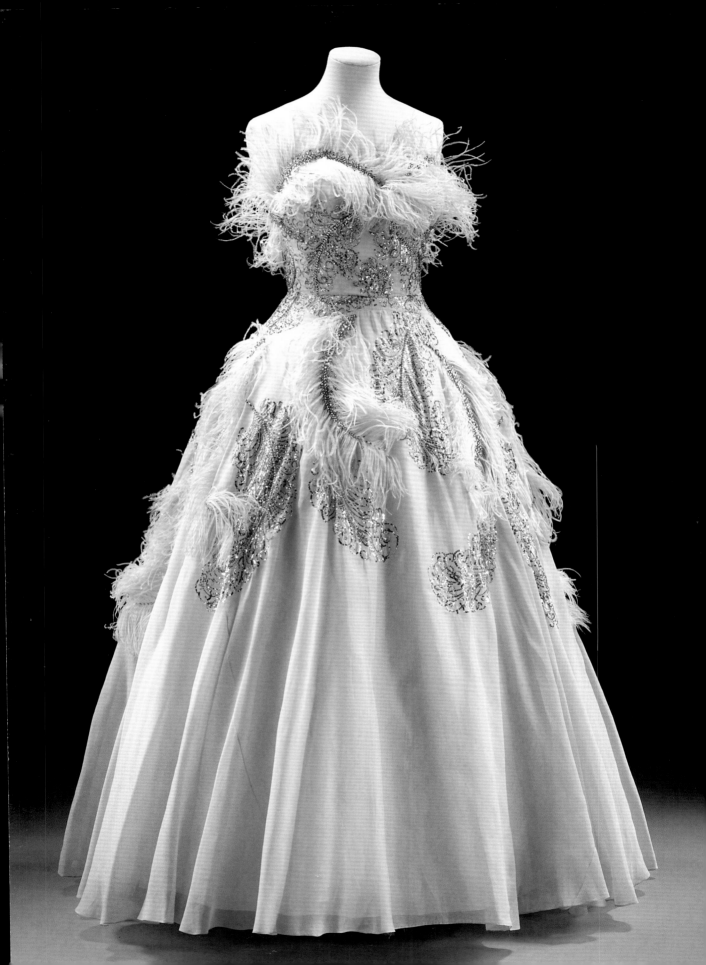

131. Ballgown (opposite)
Pierre Balmain (1914–82)
*c.*1950

This gown was commissioned for a court ball. It would have been sent to specialist embroidery and feather workshops for embellishment; meticulous patience and skill was required to work on such a delicate silk. The ostrich plumes by Lemarié are enhanced with Swarovski crystals and matched with delicate fronds of silver sequins.

Paris
Silk organza with ostrich feathers, sequins and crystals

Worn by the Hon. Mrs Pleydell-Bouverie (1895–1996)
Given by Miss Karslake
V&A: T.176-1969

132. Fashion illustration for
Harper's Bazaar
Jacques Demachy (1898–1981)
*c.*1955

Illustrations were able to capture the mood of a collection and convey the soft, tactile nature of fabrics in a way that photography could not. The drawings were often printed on special matte paper and bound into fashion magazines as inserts.

Watercolour, charcoal, Chinese white, pen and Indian ink on coloured paper

Depicts evening gown by Castillo for Lanvin
©Jean Demachy
V&A: E.686-1997

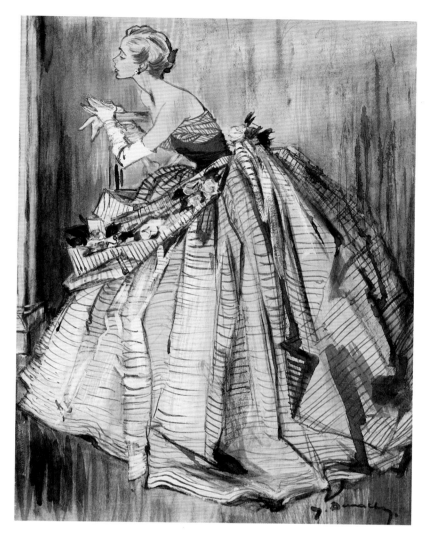

133. Shoes
Roger Vivier (1913–98) for Christian Dior
1958–60

Paris
Embroidered silk satin with beads, gilt thread, rhinestones and brilliants

Given by Mrs Loel Guinness
V&A: T.149&A-1974

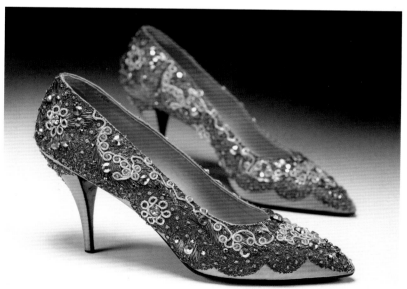

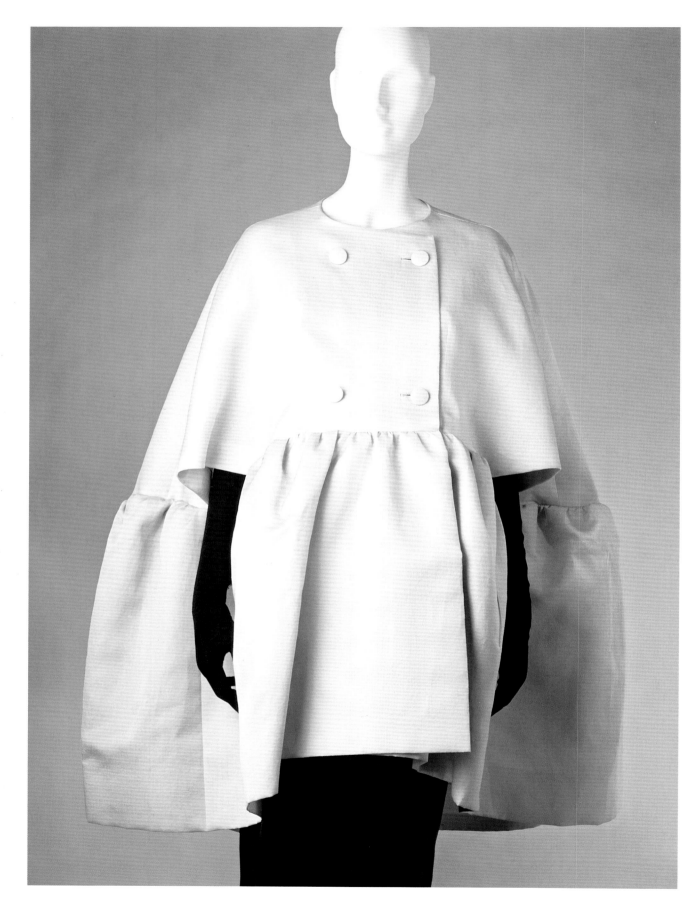

134. Evening cape (opposite)
Cristóbal Balenciaga (1895–1972)
1963

Paris
Silk gazar

Given by Mrs Loel Guinness
V&A: T.31–1974

135. Dress
Cristóbal Balenciaga (1895–1972)
1957

Balenciaga was regarded by his peers as 'the
Master'. In 1957 his 'sack' line created a stir,
because it was so radically different from the
constricting hour-glass shape that dominated
fashion. This example shows how the dress
hangs suspended from the shoulders like an
envelope around the body, letting it breathe.
The hem was shortened by 7cm in the 1960s
to bring it in line with new fashions.

Paris
Wool

Bequeathed by Mrs Dittenhofer
V&A: T.90–1973

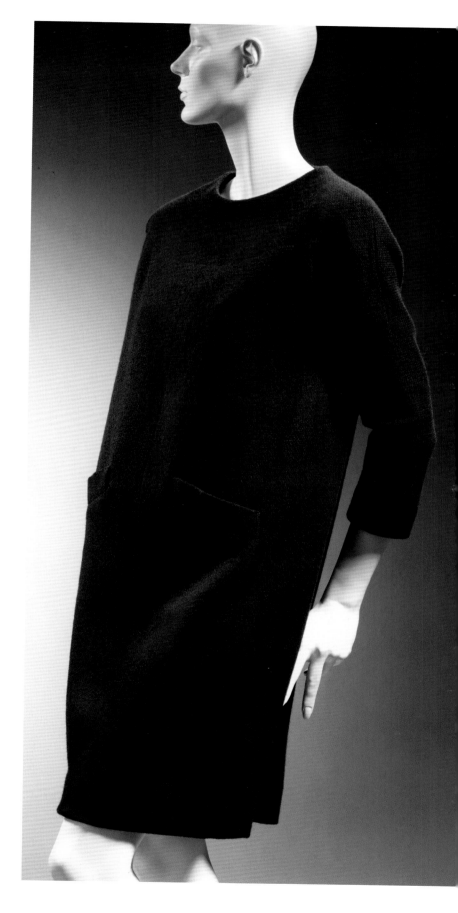

Revolution

1960
–1969

A new generation of designers brought fresh ideas to the making and retailing of clothes, experimenting with materials such as plastic and paper to create disposable fashions. Designers such as Mary Quant successfully challenged the dominance of Paris fashion and opened boutiques selling affordable, youthful styles; their creations became successful exports epitomizing 'Swinging London'.

Fashion-conscious young men set out to challenge the staid rules of masculine etiquette that had prevailed since Victorian times. They forged new styles of dress creating the modern dandy, a flamboyant figure in bright colours and rich fabrics, whose adventurous wardrobe perfectly suited the creative atmosphere of the time.

Paper dress (detail of pl.146)
1967

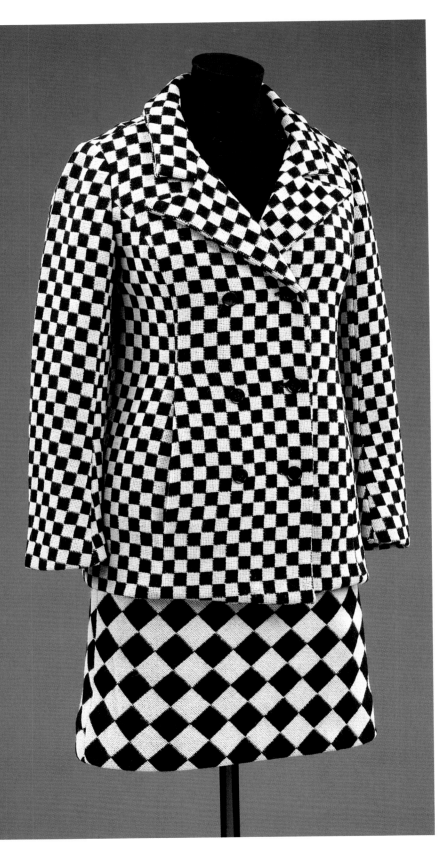

136. Skirt and jacket
Marion Foale (b.1939) & Sally Tuffin (b.1938)
1964

Inspired by Op Art, Foale & Tuffin's tailored suit brought the Mod Look to the pages of *Vogue* under the heading 'Checkerboard tweed to blind the eye'. It retailed at the King's Road boutique Top Gear and Knightsbridge department store Woollands. A version of the suit with trousers was also available.

London
Wool
Worn by Marit Allen
V&A: T.43:1&2-2010

137. Earrings
Wendy Ramshaw (b.1939) and David Watkins (b.1940)
1963-5

London
Screen-printed acrylic Perspex and metal

Made by Optik Art Jewellery
Given by the designers
V&A: T.338C& D

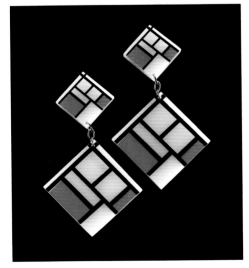

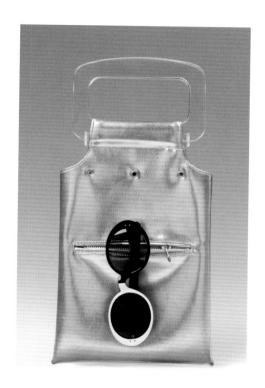

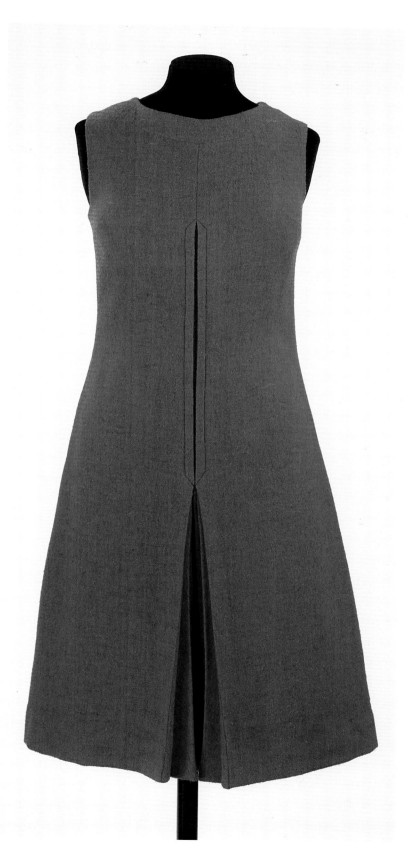

138. Sunglasses, 'Milinaire'
Oliver Goldsmith Eyewear
1967

Great Britain
Plastic

Given by A. Oliver Goldsmith, in memory of
his father, Charles Oliver Goldsmith
V&A: T.244E–1990

shown on image with

Handbag
Sally Jess (b.1940)
1966

London
Silvered plastic with Perspex handles

Given by Mr John Jesse
V&A: T.332–1982

139. Dress
Mary Quant (b.1934)
1960

London
Wool tweed

Worn and given by Mrs Margaret Stewart
V&A: T.27–1997

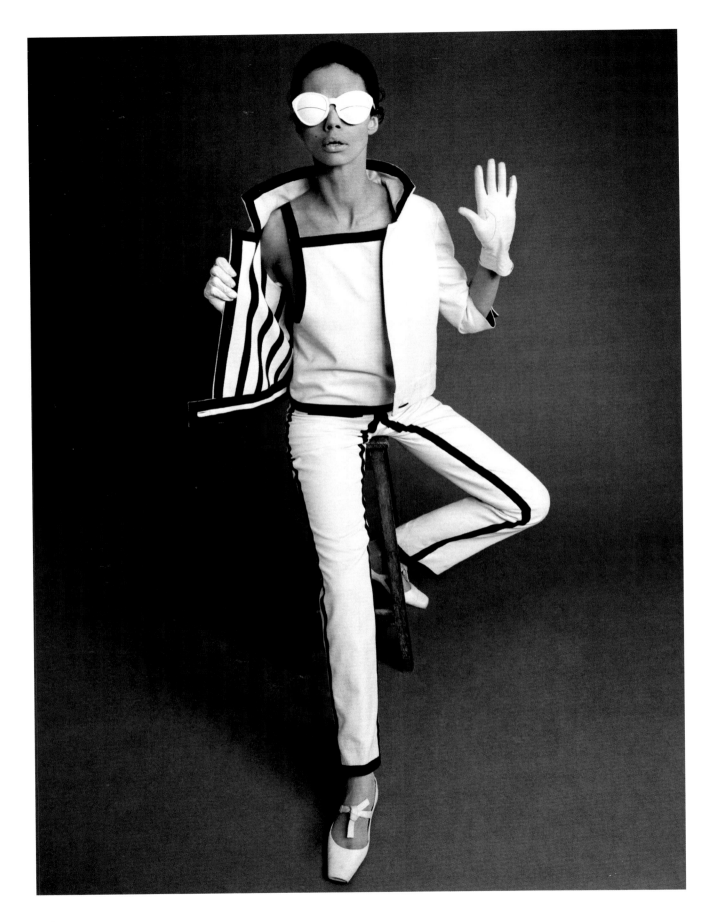

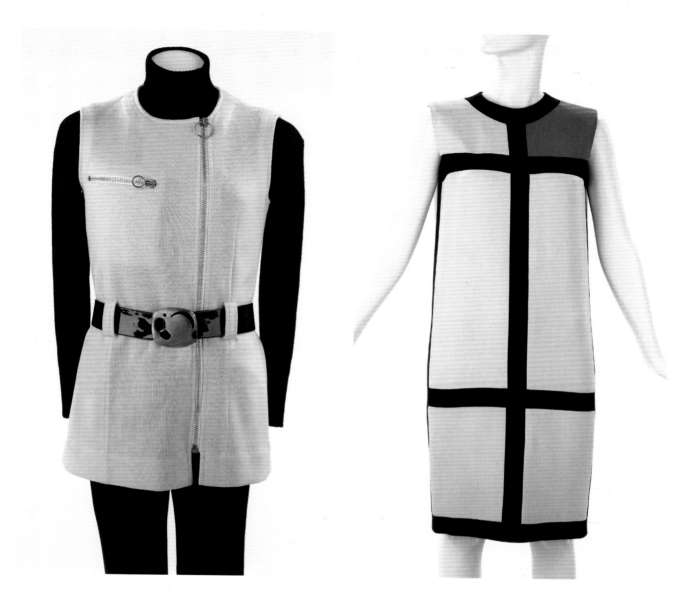

140. Fashion Photograph (opposite)
Photograph by John French (1907-66)
1965

Gabardine trouser suit with gloves, shoes
and sunglasses by Andre Courreges, modelled
by Simone d'Aillencourt

V&A: AAD/1979/9/JF6821

141. 'Cosmos' ensemble (above, left)
Pierre Cardin (b.1922)
1967

Woollen jersey, with patent leather belt and boots

Given by the designer
V&A: T.703 to C-1974

142. 'Mondrian' dress (above, right)
Yves Saint Laurent (1936-2008)

Silk crepe

Given by the designer
V&A: T.369-1974

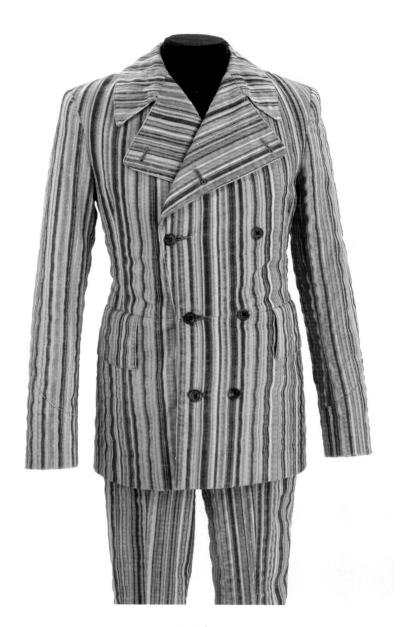

144. Ties
Emilio Pucci (1914–92)
1965–75

Italian fashion began to emerge after the war, with designers like Emilio Pucci providing sophisticated clothes for the jet set. Pucci became one of the first designers to use a signature style for high-status fashion licensing. His vivid printed silks express the psychedelic mood of the late 1960s and early '70s.

Italy
Printed silk

Given by G.A. Browning
V&A: T.453 to 462–1985

143. Suit
Mr Fish (b.1940)
1967

Michael Fish opened his tailor's shop in 1966 near Savile Row, having introduced fitted shirts and kipper ties to the traditional hosier Turnbull & Asser. This suit was made to measure using furnishing fabric found in the USA by client David Mlinaric, the interior designer.

London
Printed cotton furnishing corduroy by Hexter (USA)

Worn and given by David Mlinaric
V&A: T.310&A–1979

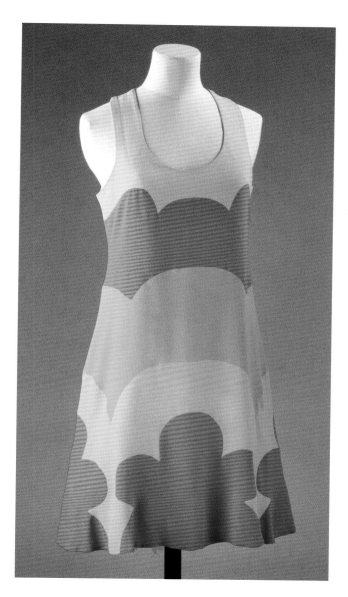

146. Paper dress (right)
Dispo (Meyersohn & Silverstein Ltd)
1967

Although impractical, paper dresses were perfect for bold, graphic Pop prints. Diane Meyersohn studied art nouveau designs at the V&A, resulting in this print for her 'Dispo' range. It came top in a *Which?* magazine test, as it was fire-resistant, washable and 'still going strong after six wearings'.

London
Bonded cellulose fibre ('Bondina')
with printed design

Given by Diane Meyersohn
V&A: T.176–1986

145. Dress (left)
John Kloss (1937–87)
1966

New York
Silk crepe
V&A: T.259–2009

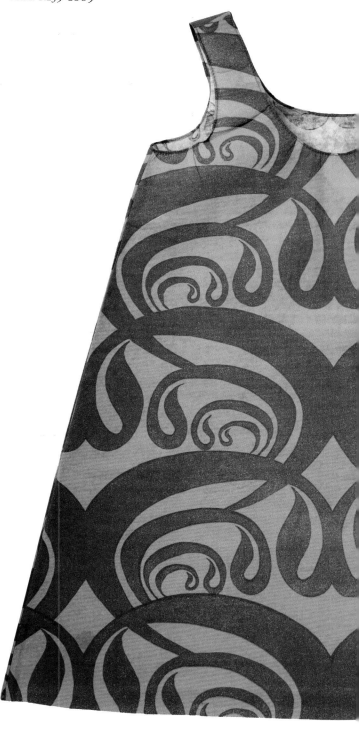

Patterning Fashion

1967 —1975

By the late 1960s, the London store Biba had become a magnet for the young, selling 1930s and '40s inspired clothes, make-up, accessories and even household products, all bearing the distinctive gold and black label. Dresses and T-shirts had tight sleeves and earthy colours, while 'glam' evening wear drew on Art Deco styles.

Surface pattern became increasingly important. Zandra Rhodes specialized in screen-printed textiles before going on to design her own collections, Thea Porter created luxurious kaftan dresses inspired by the Middle East, and Ossie Clark, working in collaboration with textile designer Celia Birtwell, reflected a new romanticism with delicate chiffon creations.

Shirt (detail of pl.153)
1968–70

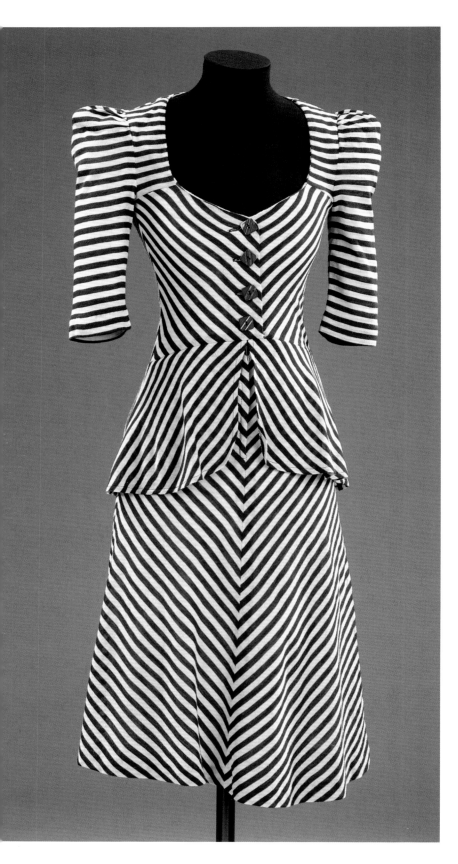

147. Dress
Biba
1970–71

Synthetic jersey
Given by Barbara Hulanicki
V&A: T.120–2011

148. Platform sandals (below)
Emma of London
c.1972–3

Britain
Lurex, synthetic fibres and plastic
Retailed by Biba
Worn and given by Karen Gunnell
V&A: T.460&A–1988

149. Dress (opposite)
Biba
1973

Barbara Hulanicki (b.1936) created romantic
but affordable garments for a generation swept
up in the growing craze for vintage dresses.
Her textile designs were called 'granny prints'
in the Biba mail order catalogues. The mono-
chrome pattern of this midi-length dress recalls
the glamour of Art Deco, while the tight puffed
sleeves and high collar are reminiscent of late
nineteenth-century dress styles.

London
Printed acrylic jersey
Given by Karina Garrick
V&A: T.203–1991

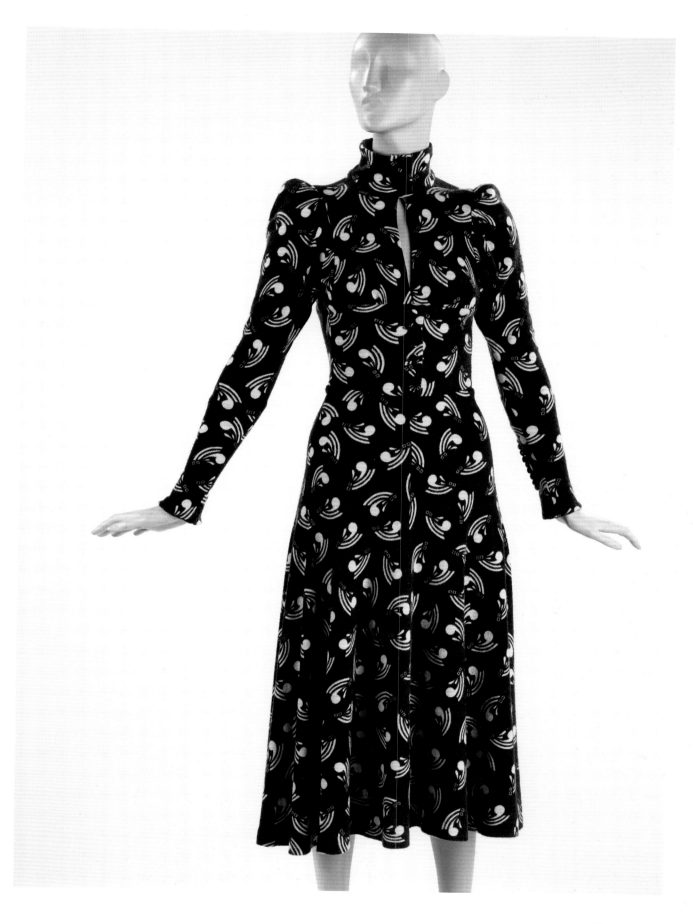

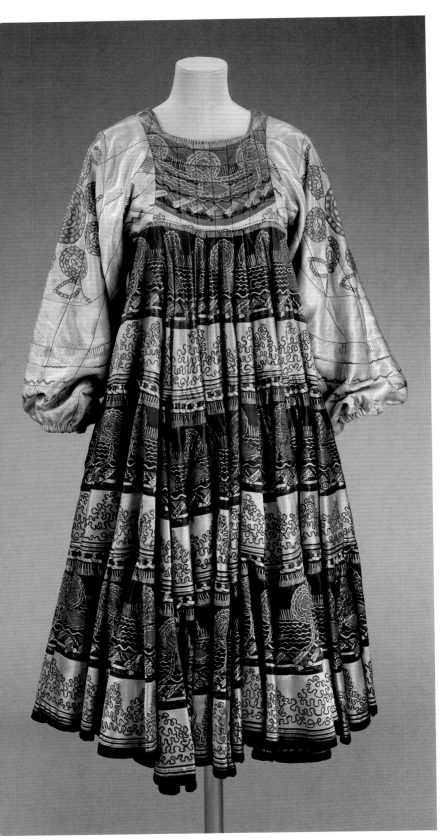

150. Dress
Zandra Rhodes (b.1940)
1969–70

London
Screen-printed satin with quilting
V&A: T.400–1980

151. Fashion design
Bill Gibb (1943–88)
Autumn/Winter 1976

Britain
Ink on paper with leather and fabric samples
V&A: E.128–1978

152. Dress (opposite)
Thea Porter (1927–2000)
1970

London
Chiffon, figured silk and velvet
Supported by the Friends of the V&A
V&A: T.900–2000

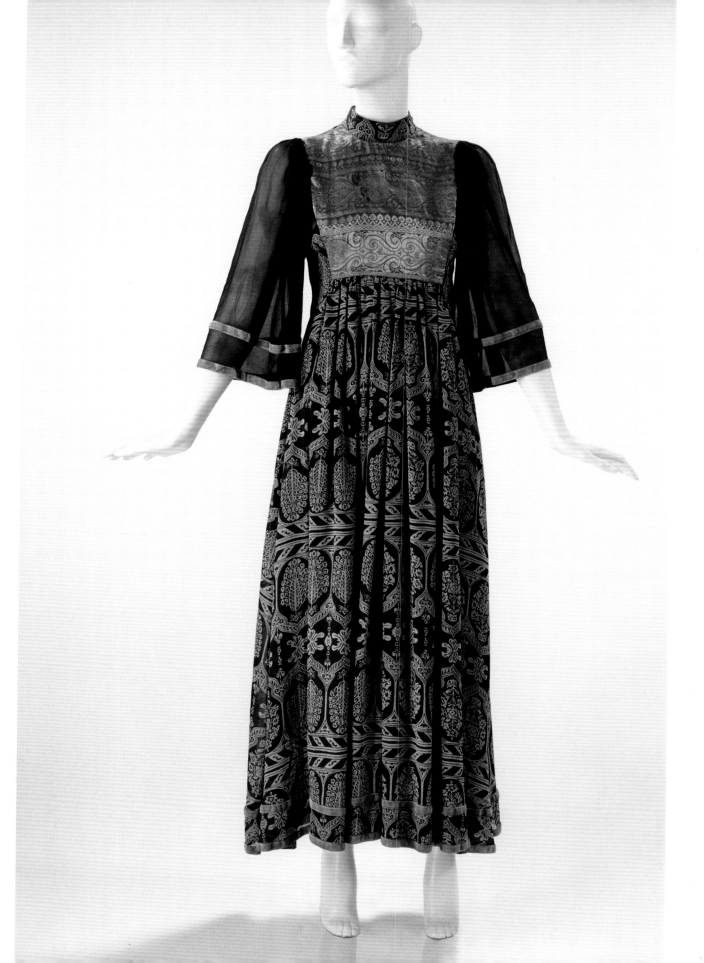

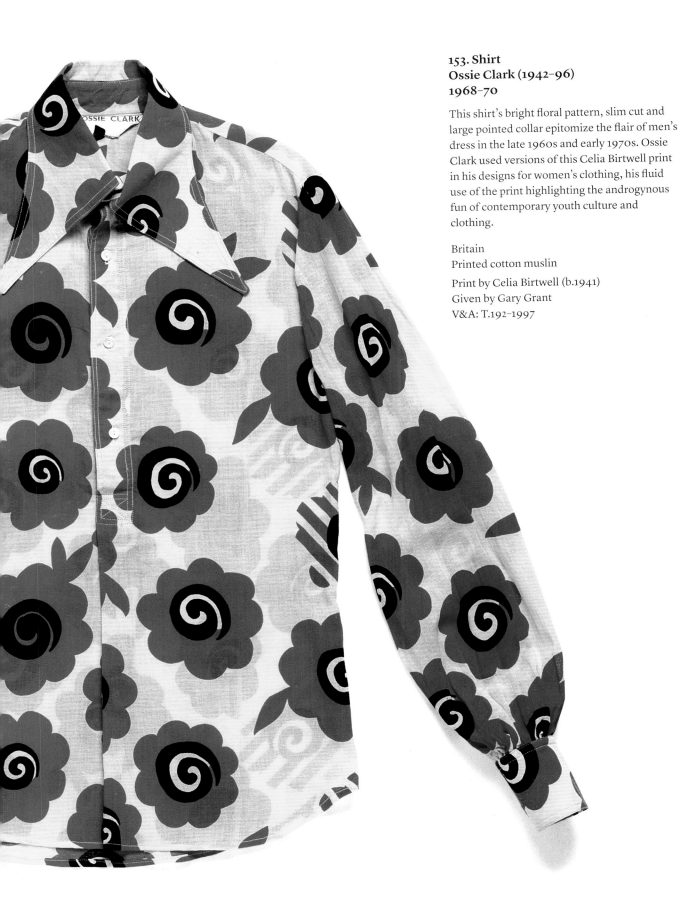

153. Shirt
Ossie Clark (1942–96)
1968–70

This shirt's bright floral pattern, slim cut and large pointed collar epitomize the flair of men's dress in the late 1960s and early 1970s. Ossie Clark used versions of this Celia Birtwell print in his designs for women's clothing, his fluid use of the print highlighting the androgynous fun of contemporary youth culture and clothing.

Britain
Printed cotton muslin

Print by Celia Birtwell (b.1941)
Given by Gary Grant
V&A: T.192–1997

154. Sweater
The Ritva Man
Artists' Collection
Designed by Mike Ross (b.1936)
in collaboration with David Hockney (b.1937)
1971

London
Machine-knitted acrylic
with embroidered appliqué

Given by Mike Ross
V&A: Circ.182–1972

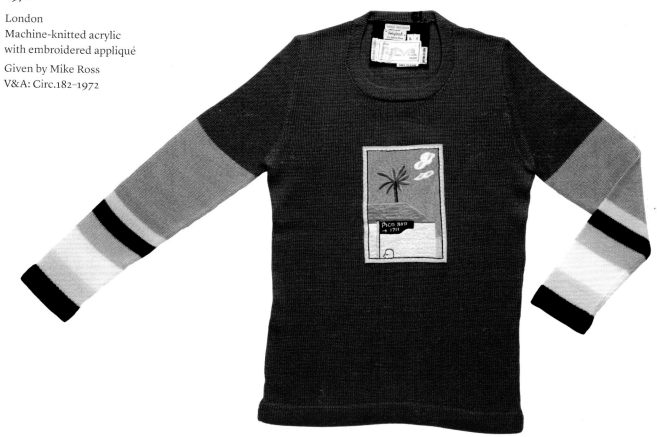

155. Shoe
Terry de Havilland
1972

London
Snakeskin, leather and cotton

Given by David Shilling
V&A: T.78–1983

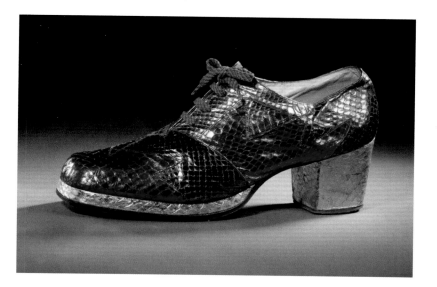

Decon-
structing
Fashion

1975–1985

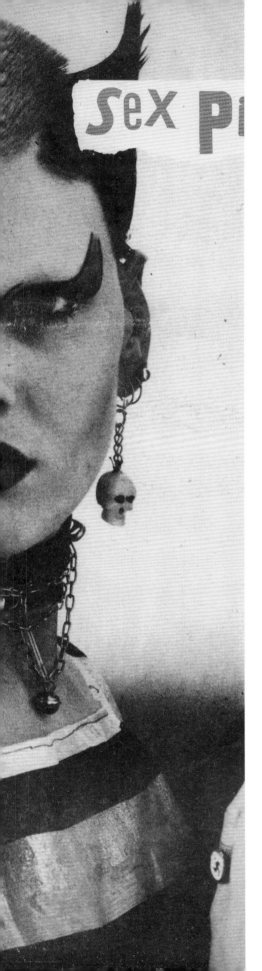

During the late 1970s, Vivienne Westwood and Malcolm McLaren's shop in King's Road was at the centre of London's emerging punk movement. Closely associated with bands such as the Sex Pistols, punk was anti-establishment, androgynous and improvised; its influence is still felt today in graphics, music and fashion.

The British designer John Galliano graduated in 1984 from Central St Martins with a collection, *Les Incroyables*, inspired by the French Revolution. He later went on to design for Givenchy and Dior. In the same decade Japanese designers such as Rei Kawakubo (designing under the name Comme des Garçons) and Yohji Yamamoto began to show in Paris and challenged conceptions of the fashionable body with oversized and asymmetrical garments predominantly in black.

Anarchy in the UK (detail of pl.159)
1977

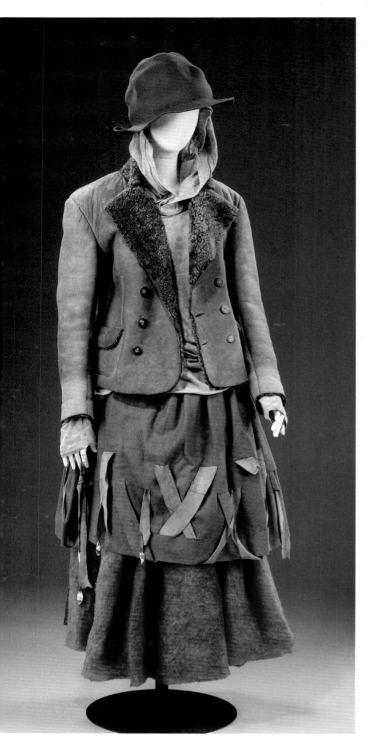

156. Ensemble
Malcolm McLaren (1946–2010) and
Vivienne Westwood (b.1941)
Nostalgia of Mud collection, Autumn/Winter 1982–3

The *Nostalgia of Mud* collection was shown in London and Paris. It featured sheepskin jackets, satin brassières worn as over-garments, felt hats, 'fall down' leather boots and swirling skirts with printed borders showing dancing Peruvian women. McLaren and Westwood found their inspiration in the pages of *National Geographic* magazine.

England
Felt, Dacron, cotton and leather

Worn by Gerlinde Costiff
Purchased with the assistance of The Art Fund, the Friends of the V&A, the Elspeth Evans Trust and the Dorothy Hughes Bequest
V&A: T.108:1–2002; T.139:1,2–2002; T.140:1,2–2002; T.141:1,2–2002

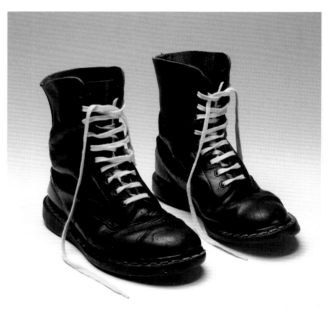

157. Boots
Dr. Martens
*c.*1980

England
Leather and rubber

Given by Revamp, Brighton
V&A: T.102:1,2–1994

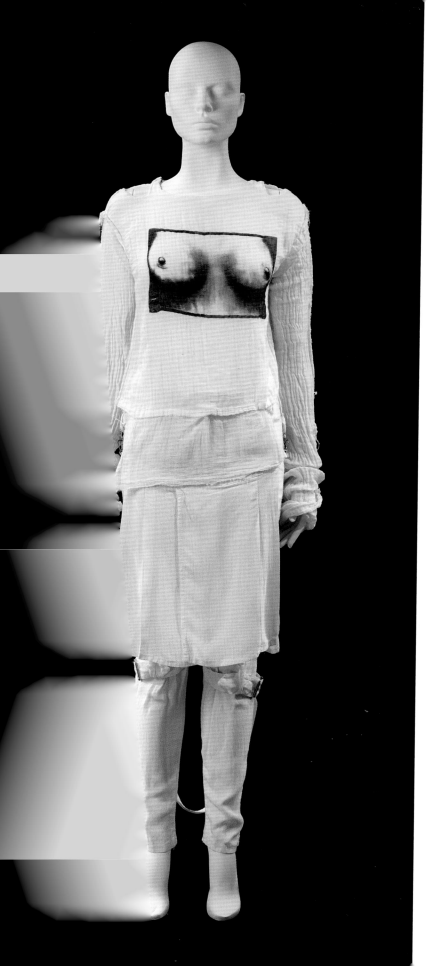

158. Ensemble
Malcolm McLaren (1946–2010)
and Vivienne Westwood (b.1941)
1976

Printed muslin, nylon and cotton

Trousers and kilt retailed by BOY
Purchased with the assistance of The Art Fund,
the Friends of the V&A, the Elspeth Evans
Trust, and the Dorothy Hughes Bequest
V&A: T.90 & 91–2002

159. *Anarchy in the UK*
1977

London
Lithographic print on newsprint

Jamie Reid archive
V&A: S.951–1990

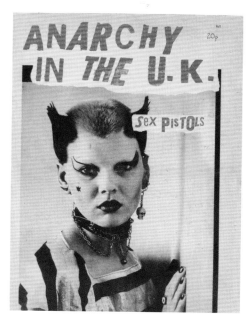

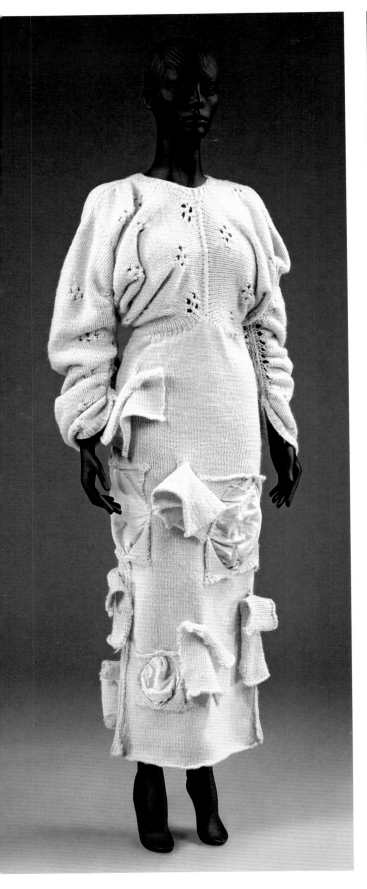
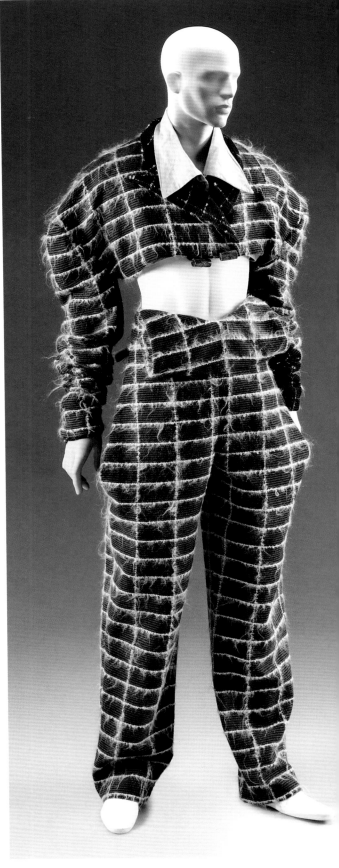

160. Dress
John Galliano (b.1960)
1984

England
Knitted wool and cotton

Given by Slim Barrett
V&A: T.922–2000

161. Suit
John Galliano (b.1960)
***The Ludic Game* collection**
Autumn/Winter 1985

London
Wool, mohair and cotton

Given by Bouke de Vries
V&A: T.223&A–1989, T.224B–1989

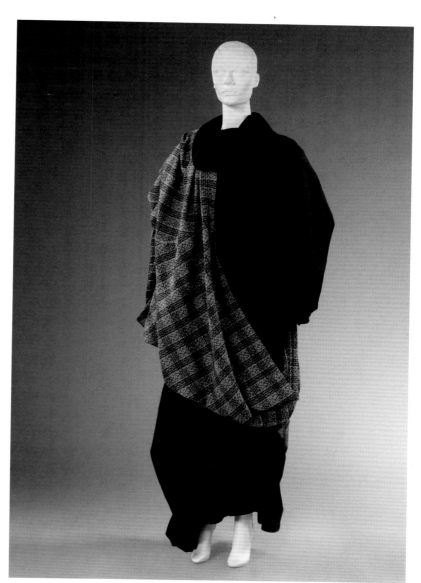

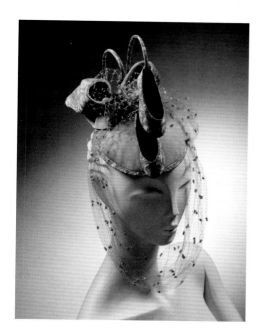

162. Hat 'Pas des Deux'
Stephen Jones (b.1957)
1982

London
Velvet, brocade, net and wire

Given by the designer
V&A: T.62–1983

163. Ensemble
Comme des Garçons
1983

The Japanese designer Rei Kawakubo caused consternation when she began showing in Paris in 1981. Working in a muted palette of blacks and greys, and offering a new aesthetic based on drape rather than tailoring, her voluminous wrappings challenged existing conceptions of beauty. She said: 'Perfect symmetry is ugly . . . I always want to destroy symmetry.'

Tokyo
Dress and tunic: cotton and elastic
Sweater: wool

Given by the designer
V&A: T.168 to B–1985

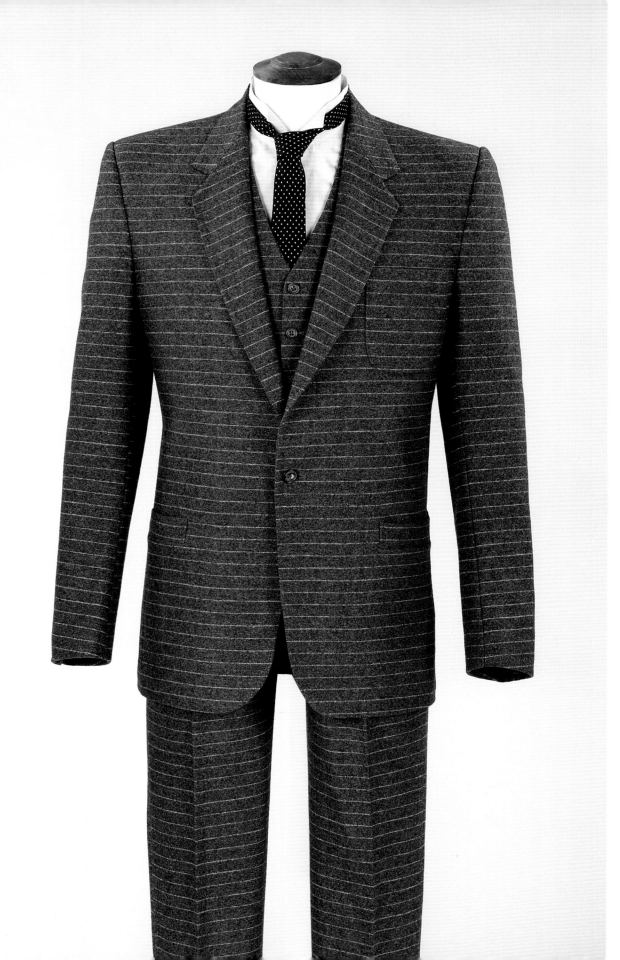

164. Suit, shirt and tie (opposite)
Tommy Nutter (1943–92)
1983

London
Wool, cotton and silk

Given by the designer
V&A: T.10 to B–1983

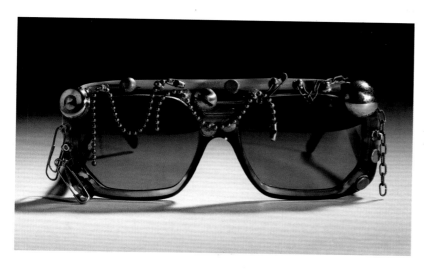

165. Sunglasses 'Sloanes to a Punk Party'
Oliver Goldsmith Eyewear
*c.*1985

Britain
Plastic and metal

Given by A. Oliver Goldsmith, in memory of his father, Charles Oliver Goldsmith
V&A: T.245B–1990

166. 'Watch' Shoes
Red or Dead
1988

Britain
Leather, plastic and metal

Given by Red or Dead
V&A: T. 115&A–1989

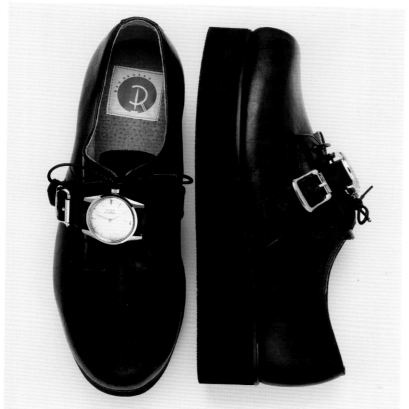

Fashion
Now

1990
—2012

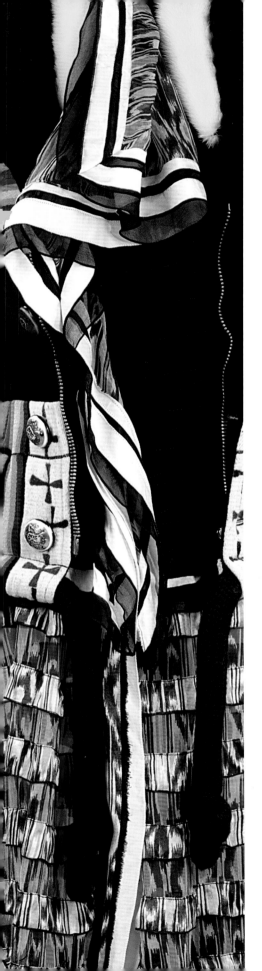

Menswear shows in Milan and Paris have become increasingly important events in the fashion calendar. In the 1990s, collector Mark Reed bought many flamboyant outfits by designers such as Jean Paul Gaultier. Wearing them to London art openings, he said, 'I think people have forgotten how to dress.' 'Stealth luxury' was an increasingly dominant trend, as the fashion cognoscenti began to reject overt labelling and logos in favour of functional essence. Such pared-back designs required a fully toned body and encouraged a revival in body-shaping underwear.

Top fashion houses continue to exert their influence through catwalk collections, but the trend towards 'designers for the high street' has provided instant, affordable high design for everyone. The Internet has also had a powerful impact on fashion, from global forecasting websites to individual blogs, online fashion magazines and e-tailing.

Jacket and dress (detail of pl.174)
2007

167. Dress
Jean Paul Gaultier (b.1952)
Spring/Summer 1991

Paris
Printed stretch synthetic with sequins

Anonymous gift
V&A: T.90–2012

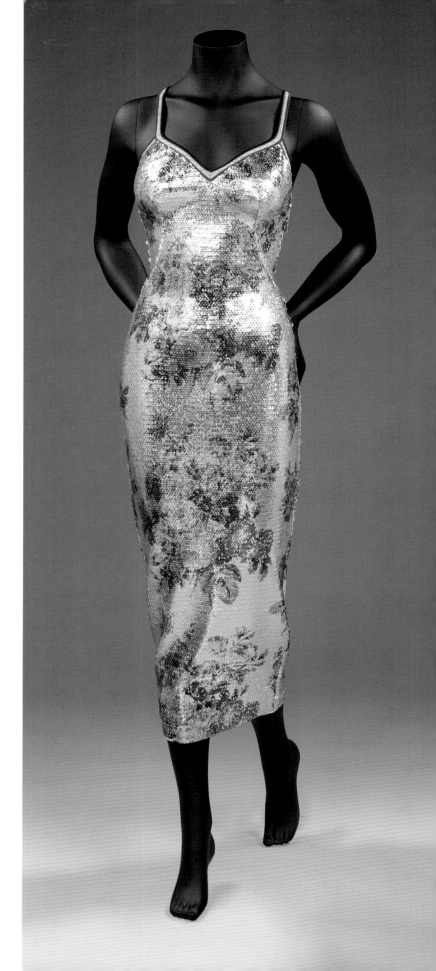

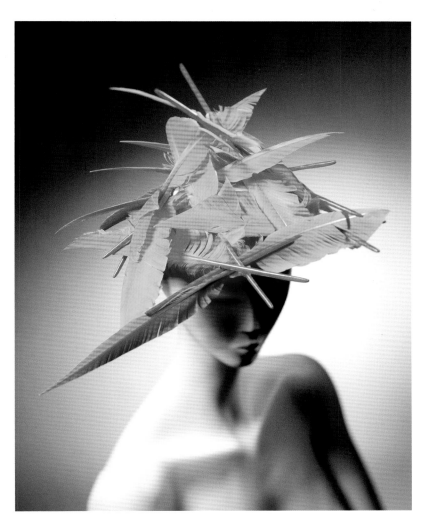

168. Hat
Philip Treacy (b.1967)
1995

London
Hand-stitched dyed goose feathers

Given by the designer
V&A: T.182-1996

169. Shoes
Vivienne Westwood (b.1941)
1993-4

London
Punched leather with silk ribbon laces

Given by the designer
V&A: T.225:1&2-1993

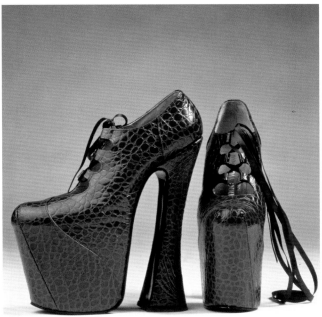

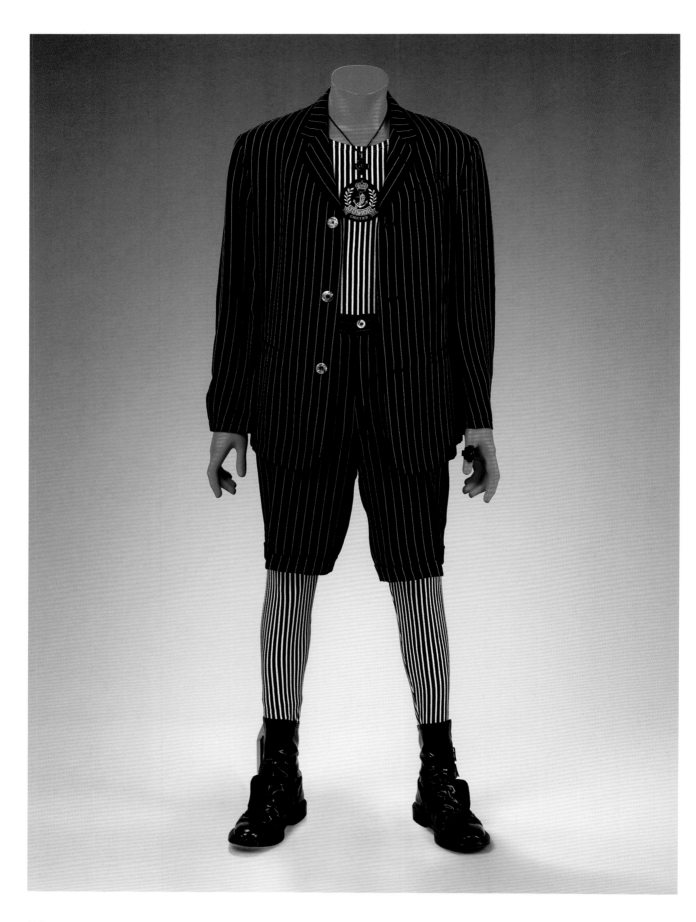

170. Shorts suit (opposite)
**Jean Paul Gaultier
(b.1952) for
Junior Gaultier**
*c.*1995

France (designed)
Italy (made)
Suit: rayon, cotton and
spandex blends
Boots: patent leather

Worn and given by Mark Reed
V&A: T.22:1 to 4–2011;
T.86:1,2–2011

**171. Suit
Rei Kawakubo (b.1942)
for Comme des Garçons
1995**

France (designed)
Japan (made)
Suit: cotton
Shoes: cotton and rubber

Worn and given by Mark Reed
V&A: T.6:1 to 7–2011

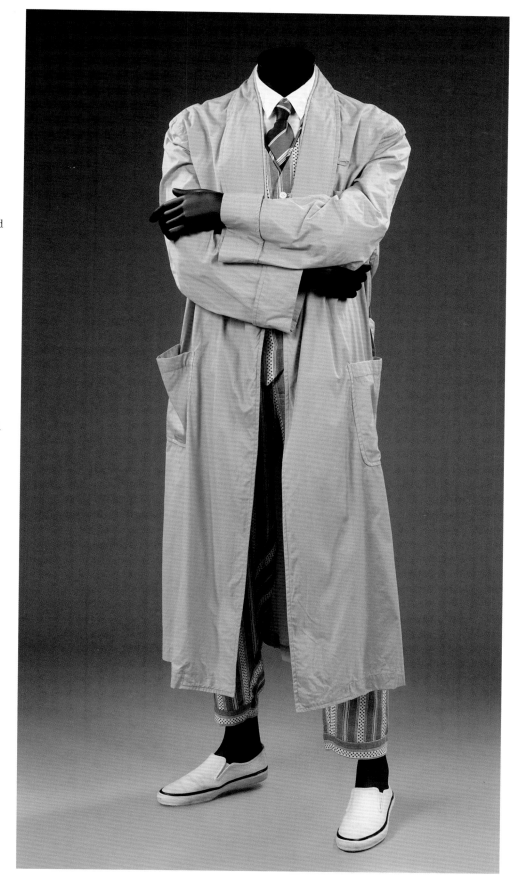

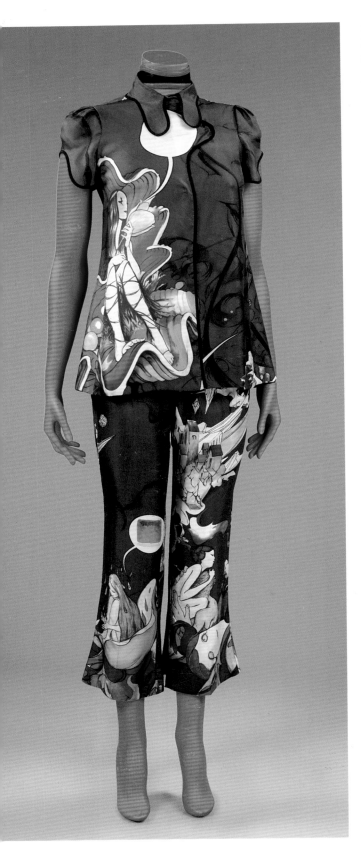

172. Ensemble
Prada
Spring/Summer 2008

Since introducing womenswear to the Prada label in 1989, Miuccia Prada's collections have become highly influential and known for their stylized silhouettes, bold motifs or patterns and statement accessories. This outfit incorporates Art Nouveau curves and cut-outs with a delicate fairy print by comic book artist James Jean.

Italy
Shirt and trousers: printed silk
Collar: leather
Given by Prada
V&A: T.3:1, 2, 5–2009

173. Shoes
Prada
Spring/Summer 2008

Italy
Leather, velvet, moulded plastic
V&A: T.3:3,4–2009

174. Jacket and dress (opposite)
Nicolas Ghesquière (b.1971) for Balenciaga
2007

Paris
Jacket: wool, mink, printed silk
Dress: printed silk
V&A: T.116:1,2–2011

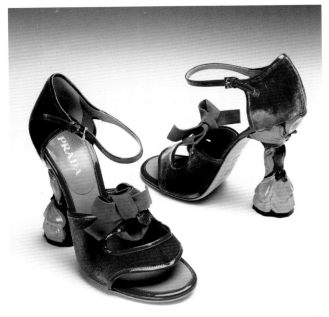

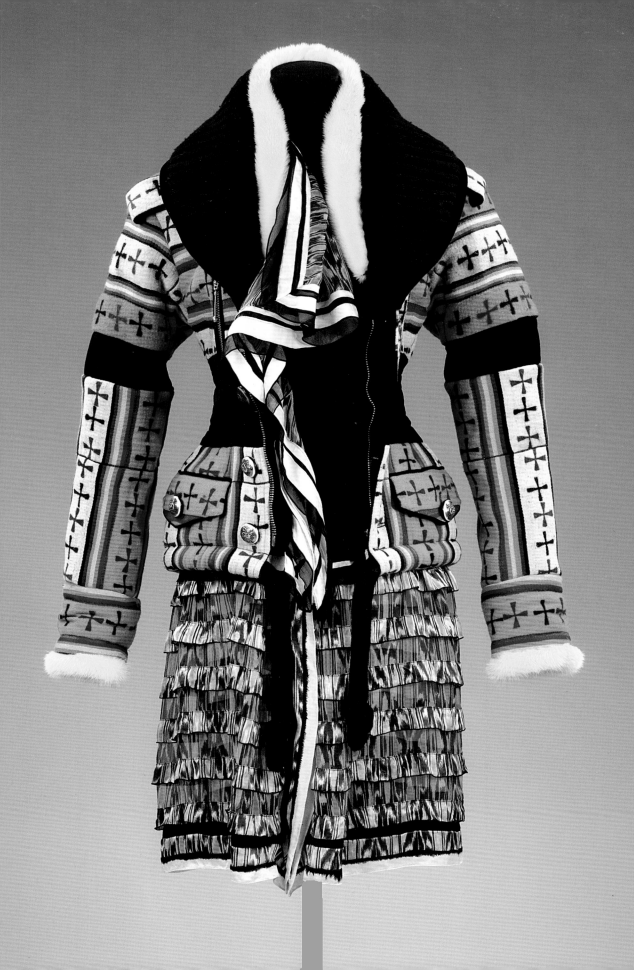

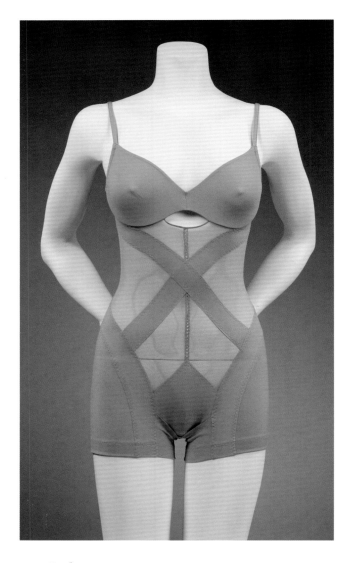

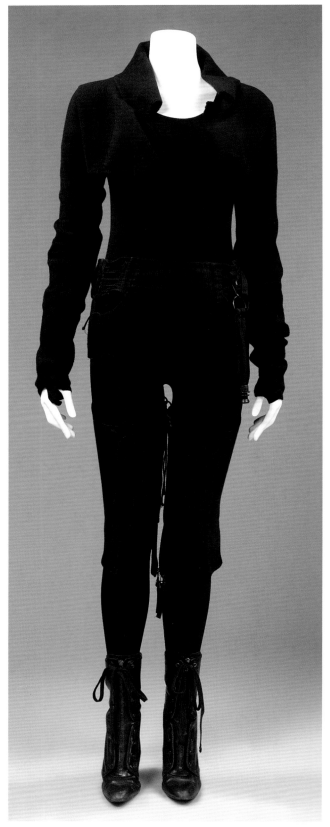

175. Body
La Perla
2011

Italy
Cotton and lycra
Given by La Perla
V&A: T.58–2012

176. Ensemble
Helmut Lang (b.1956)
2003

USA (designed)
Italy (made)
Wool, cashmere and cotton with lycra, cotton and leather
Given by the designer
V&A: T.55:1 to 6–2010

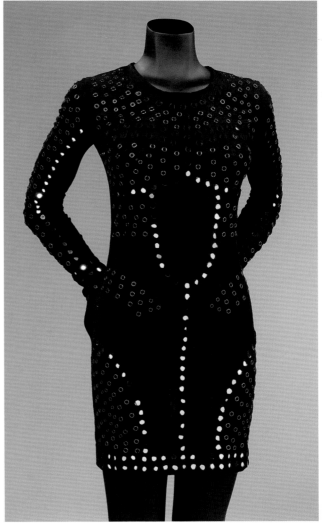

177. Top and skirt
Calvin Klein (b.1942)
Spring/Summer 1996

USA
Jersey
Given by the designer
V&A: T.251:1,2–1997

178. Dress
Christopher Kane (b.1982) for Top Shop
2009

London (designed)
India (made)
Nylon, elastane, metal and glass
V&A: T.20–2010

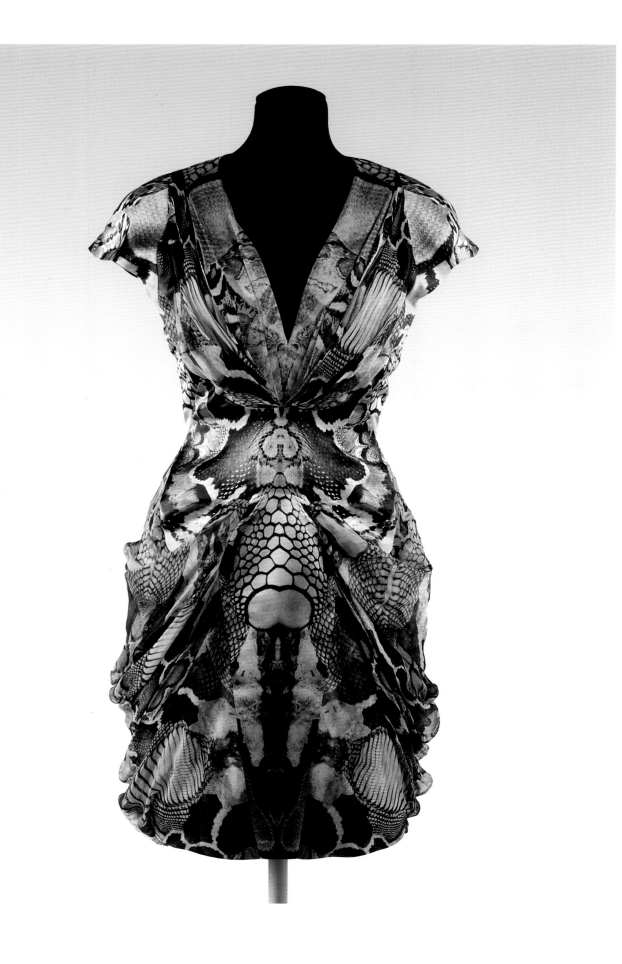

179. Dress (opposite)
Alexander McQueen (1969–2010)
Plato's Atlantis **collection**
Spring/Summer 2010

London (designed)
Italy (made)
Digitally printed silk
V&A: T.11–2010

180. Bag (below)
Alexander McQueen (1969–2010)
Spring/Summer 2011

London
Metal and leather
V&A: T.108–2011

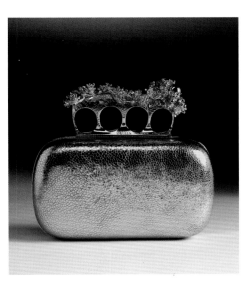

181. Coat
Alexander McQueen (1969–2010)
*c.*1995

London (designed)
Italy (made)
Cashmere blend embroidered with silk thread

Worn and given by Mark Reed
V&A: T.33–2011

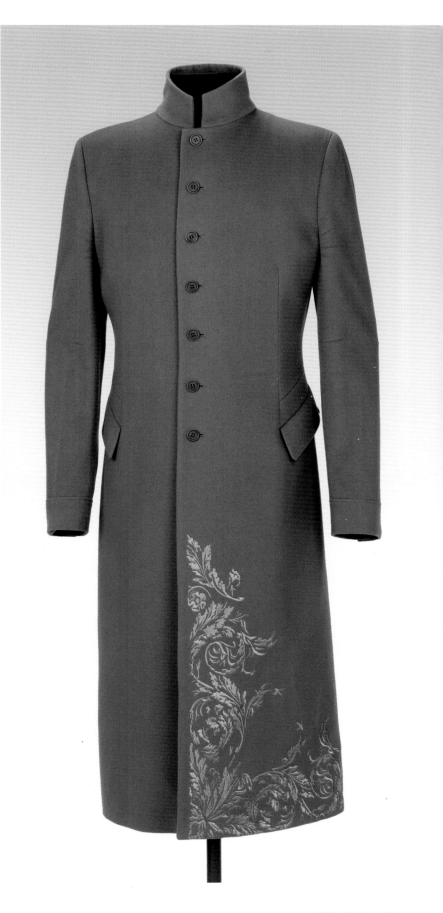

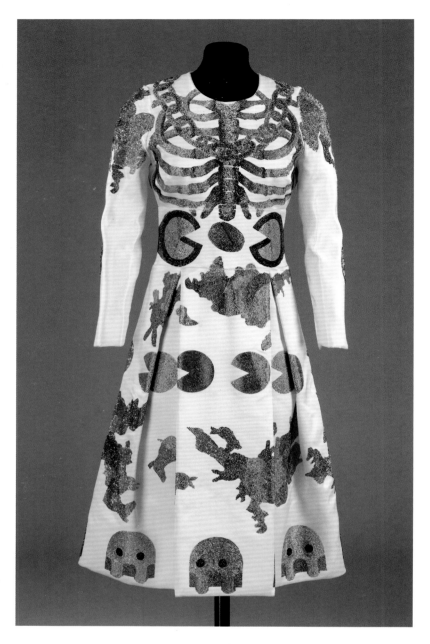

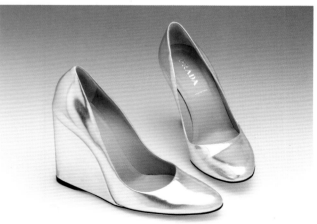

182. Dress
Giles Deacon (b.1969)
2008

London
Silk and Swarovski crystal
Given by the designer
V&A: T.19-2010

183. Shoes
Prada
2005

Italy
Leather
Given by Lady Jill Ritblat
V&A: T.261:1, 2-2011

184. Dress (opposite)
Gareth Pugh (b.1981)
2011

London or Paris
Silvered leather
V&A: T.135:1, 2-2011

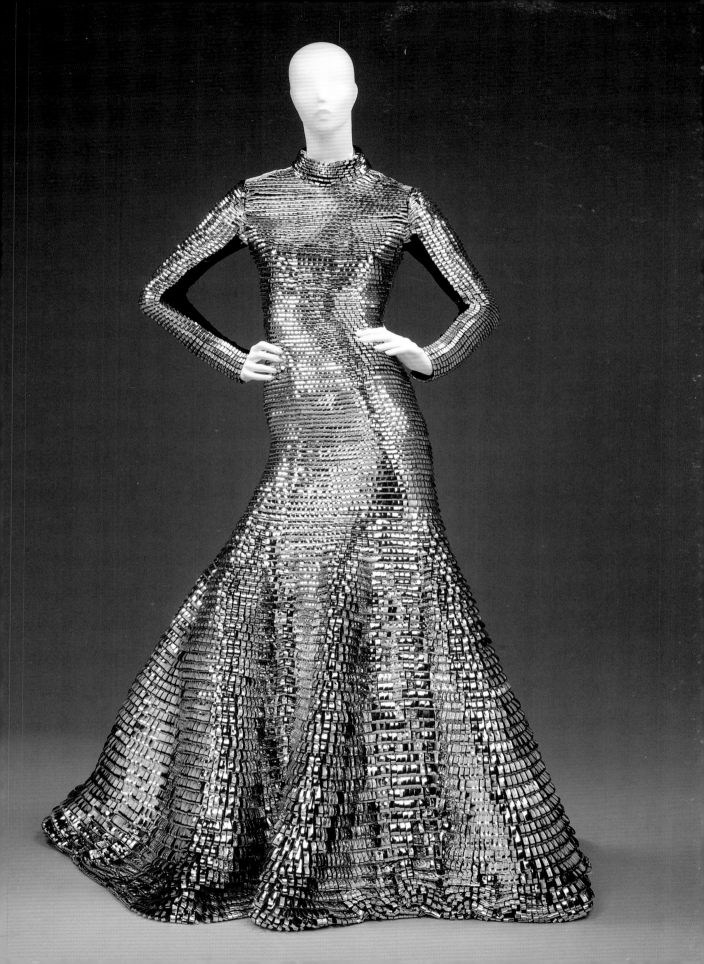

Further reading

Sonia Ashmore, *Muslin* (2012)

Christopher Breward, David Gilbert, Jenny Lister (eds), *Swinging Sixties* (2006)

Clare Browne, *Lace from the Victoria and Albert Museum* (2004)

Amy De la Haye and Valerie Mendes, *Lucile Ltd* (2009)

Amy De la Haye (ed), *The Cutting Edge: 50 Years Of British Fashion 1947-1997* (1997)

Edwina Ehrman, *The Wedding Dress* (2011)

Avril Hart, *Ties* (1998)

Avril Hart and Susan North, *Seventeenth and Eighteenth Century: Fashion in Detail* (2002)

Avril Hart and Emma Taylor, *Fans* (1998)

Lucy Johnston, *Nineteenth Century Fashion in Detail* (2005)

Stephen Jones and Oriole Cullen, *Hats: An Anthology* (2009)

H. Kristina Haughland, Jenny Lister and Samantha Erin Safer, *Grace Kelly Style* (2010)

Eleri Lynn, *Underwear Fashion in Detail* (2010)

Suzanne Lussier, *Art Deco Fashion* (2003)

Lesley Ellis Miller, *Balenciaga* (2007)

Susan North and Jenny Tiramani (eds), *Seventeenth-Century Women's Dress Patterns: Books One and Two* (2011 and 2012)

Alexandra Palmer, *Dior* (2009)

Lucy Pratt and Linda Woolley, *Shoes* (1999)

Natalie Rothstein (ed), *Four Hundred Years of Fashion* (1984 and 1992)

Ligaya Salazar (ed), *Yohji Yamamoto* (2011)

Sonnet Stanfill, *New York Fashion* (2007)

Claire Wilcox, *Bags* (1999)

Claire Wilcox (ed), *The Golden Age of Couture: Paris and London 1947-1957* (2007)

Claire Wilcox (ed), *Radical Fashion* (2003)

Claire Wilcox, *Vivienne Westwood* (2004)

Claire Wilcox and Valerie Mendes, *Twentieth Century Fashion in Detail* (1998)

Collections

There are over 100 museums in the UK with significant collections of fashion and textiles.
For further details see www.dressandtextilespecialists.co.uk
The following museums have temporary exhibitions and/or displays of their permanent collections.
It is advisable to check opening arrangements before visiting.

Fashion Museum, Bath
Ulster Museum, Belfast
Brighton Museum and Art Gallery
The Bowes Museum, Co. Durham
Chertsey Museum, Surrey
Royal Albert Memorial Museum, Exeter
Glasgow Museums
Lotherton Hall, Leeds
National Museums Liverpool (Walker Art Gallery and Sudley House)
Museum of London
Manchester City Galleries (Gallery of Costume, Platt Hall)
The National Trust (Killerton, Devon, Springhill, Northern Ireland and the Snowshill Collection at Berrington Hall, Herefordshire)
Norwich Castle Museum and Art Gallery
Snibston Discovery Museum, Leicestershire
Harris Museum and Art Gallery, Preston
Worthing Museum and Art Gallery